LADY GAGA
STYLE BIBLE

DATE DUE

	WITHDRAWN		

First published in Great Britain 2011
A&C Black Publishers,
an imprint of Bloomsbury Publishing Plc
49–51 Bedford Square
London
W1CB 3DP

ISBN: 9781408156636
Copyright © David Foy (text) and Getty Images
(images)

A CIP catalogue record for this book is available from
the British Library

David Foy has asserted his rights under the
Copyright, Design and Patents Act, 1988, to be
identified as the author of this work.

Cover design: Sutchinda Thompson
Book design: Evelin Kasikov
Publisher: Susan James

This book is produced using paper that is made
from wood grown in managed, sustainable forests.
It is natural, renewable and recyclable. The logging
and manufacturing processes conform to the
environmental regulations of the country of origin.

Printed and bound in China

ACKNOWLEDGEMENTS Most importantly this is for the
amazing Susan James for having the Faith, Ellen Parnavelas, big
thanks to the ever tolerant David Ward, our industrious leader
Nigel Newton, the inspired Inez, Lovely Lisa and lauded Louise
in international. The powerhouse that is Sarah Doyle, Sarah
Butler and Holly Fordham who must dread it every time the
phone rings. The exquisite Ellen Williams and all the amazing
peeps in Bloomsbury publicity .Top marks to the truly talented
Evelin Kasikov for making everything look so great, To true
superstars Paul Vale and Jamie Lee Drake for being such a
great help at the drop of a telephone shaped hat, the truly uber
cynical Andy Barr, the unrivalled Tram-Ahn Doan and Nick
Humphrey for being so enthusiastic, My fellow reptiles Louise,
Jonathan, Terry, Robin, Max and David sell sell sell......., the
amazing people I work with everyday and who I've learnt so
much from and in no particular order so no one gets offended
Isla and Mark at Barnes and Kew, Glen, Sarah and Michelle at
Blackwells CXR, Ruth Swindon at Bookworm, Paul and Inge at
City Books Hove, Kitty and Max at Daunts, Jasper, Heather,
Rebecca, Jo-Anne , Sam, Frances Gertler, Jonathan, Veronica
and Tomi at Foyles CXR. Lisa and Francesca at Foyles Festival
Hall, the venerable Venetia, the rockin Rachel, the superbly
steady Ben and the adorable Frances at Heywood Hill, The
legendary Dave Headley, Daniel and Pavla at Goldsboro
Books, Kate Agnew at Children's Bookshop, Dan and Johnny
at John Sandoe, Rebecca Evdoka at Kew, Claire at Lutyens and
Rubinstein, 'Dame' Vivian Archer , John and Sue at Newham
Bookshop, The wonderful Jessica and Marek at Primrose Hill,
Jo Adams at Stoke Newington, The truly talented Tamara and
George at Tales On Moon Lane, Suzanne, Nicola and Stuart at
Riverside Bookshop, The unrivalled Cate and Nash at Much
Ado, the highly amusing Aimi, Tony and 'superb' Jane at Slightly
Foxed, Sarah at Ibis, the perfectly poised and calm Claire at
Hampstead Waterstones, the ever organised Silv at Waterstones
Piccadilly, the Numero Uno Karin Scherer at Hatchards and
the wonderful Roger Katz. Julia Schaffer as amazing as ever.
Margo whose knowledge knows no bounds, Frank for being
such a divine intervention, mo money Magda, Mark for such
an amazing beard, Robin and Frances for just being Robin and
Frances, the west ends brightest light Stephen Simpson, Robin,
Rachel and Ian who I know have always waited for a book like
this......., On a personal level I'd like to thank the perfect Peter
Fry and Jane, the tremendous Trish Cooper, the eloquent
Eloise King and barnstorming Becky and all at Andersen , the
Marvellous Mulligans, The Awesome O'Byrne's, the super cute
Coco Fabulous for being a true friend and the handsome Mr.
Andrew, Sadaf Ahmed, Mrs C and James, Haidee and Aimee
Chuter, Annette Clark, Dave 'the Dude' Condon, Andy Cook,
the Dancey's in Italy who first heard the news, Daniel Hudspith,
Chris and all at Deep Books, Linda de La Doolin, Marcus Gipps,
Kate Gunning, Ione and Tigger Innes , the very wise Alex
Jateih, Gill and Paul Jefferies, Tim Knapman, The Krunichiva's
, Sophie and Kevin at Tibor Jones, Annie Lascaux, Lisa and
Carla Steadman who have kept me amused since the dreaded
days of optics sugar sugar over and out , Deborah Linkowski,
Maxine, Katy Mcdonnell for the never ending encouragement,
Olivia Mead, Nayla, Sheila Phillips, Niki Segnit from whom I've
learnt so much Andrew Ramen, Alison Roberts, Pat Sage and
Arthur, the uncrowned King of Ibiza Peter Adler for his amazing
attention to detail and all at Pebble London and last but
certainly never least......my MUMx

CONTENTS

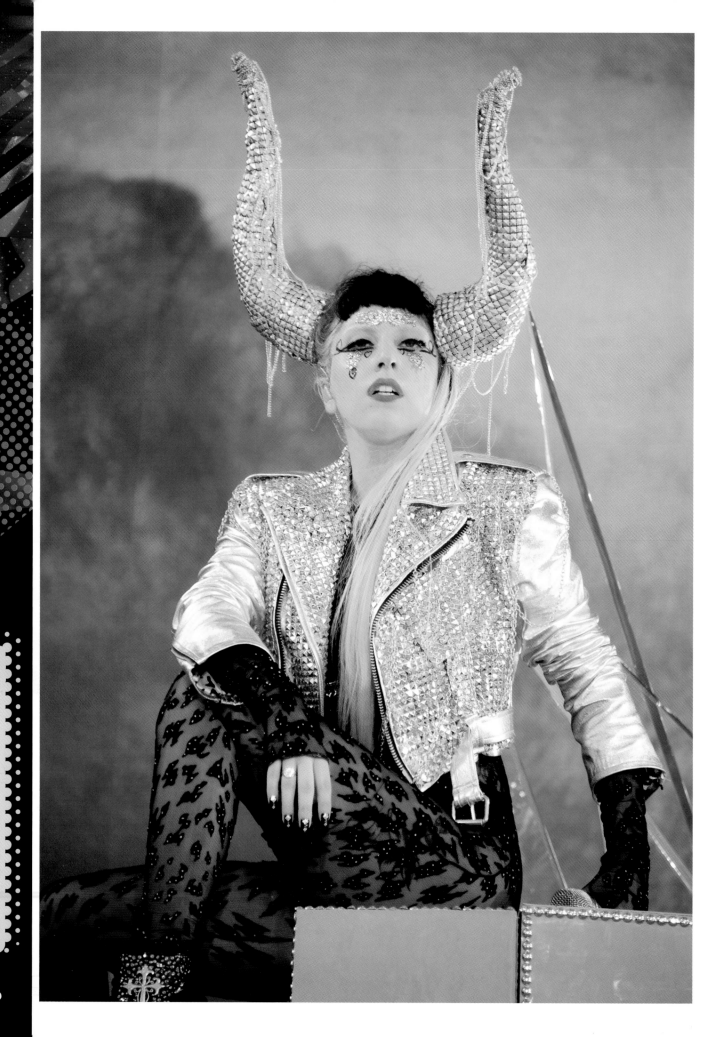

INTRODUCTION

All hail the people's warrior!
Gaga no holds barred!

Los Angeles, September 2010: Lady Gaga is advancing down the red carpet at the MTV VMAs with a military-style escort, wearing a full length gown, mohawk feathered headdress and Armadillo shoes with 12-inch heels, all by Alexander McQueen. Later that evening would come another full length gown – black leather, Armani. Of her record-breaking 13 nominations she would win eight, virtually half of all available. But what the world remembers this occasion for is her third outfit, worn to accept the final award, Video of the Year. It can only be lovingly described as BBQ couture. Her Argentinean *matambre* meat dress, cut asymmetrically with a cowl neck and matching bag, fascinator and stacked bacon-wrapped heels was not only highly original and genuinely shocking but was also convincingly tongue-in-cheek, full of attitude and the ultimate thrill for her adoring fans (her Little Monsters as she so fondly calls them). Fashion editors and paparazzi went into a frenzied overdrive. Gaga had, only days previously, had another WOW moment when she'd appeared on the cover of *Japanese Vogue* in a meat bikini but this pioneering outfit meant that the mutual love-in between her and her fans continued, leaving them smitten kittens all over again.

Tweeters and bloggers alike fought tooth and nail to be the first with a definitive analysis of what the dress – the work of Argentinean designer Franc Fernandez – was meant to mean. Gaga herself would claim it was a statement for standing up for her rights but it also links to her work to have the US Government repeal 'Don't Ask Don't Tell'. The ensemble sparked fury with animal rights group PETA, as well as sneers from world media watchers that it could not possibly have been made of real meat. Yet again though Gaga managed to make an artistic statement and post yet another love letter to the world of fashion all in one go. In essence the music didn't matter that night despite performances from Usher, Florence and the Machine, Mary J Blige and Bruno Mars and even though, by the end of the evening, she was holding gongs in eight categories she actually ended up owning the whole night.

GAGA *IN UTERO* EMBRYONIC

In the beginning there was Stefani Joanne Angelina Germanotta, eldest child of Joseph and Cynthia, born 28th March 1986. The Germanottas were a happily married couple who had worked hard to get where they were from what was a pretty average working class background. In doing so they instilled in their daughter the work ethic and drive that would keep her focussed in the middle of the media storm. From her arrival on the international pop scene at the start of 2009 she was, within months, named by Barbara Walters as one of the 10 most fascinating people of the year, and in April 2010 voted fifth in *Time Magazine's* list of the Top 100 influential people.

The prodigious Stefani began learning to play the piano aged four and was writing her first piano ballad at 13. At 14 she started out in the spotlight at open-mike nights and felt for the first time the unforgiving and always questioning eyes of a New York audience. Raised a Roman Catholic she attended the prestigious Convent of the Sacred Heart, a private all-girls Roman Catholic school on Manhattan's Upper East Side (allegedly the inspiration for *Gossip Girl*), with former alumni including Paris and Nicky Hilton and (the slightly more high-end) Caroline Kennedy, daughter of JFK.

Keen to explore all areas of performance she played some much admired amateur roles in high school musicals; she took on the role of Adelaide in *Guys and Dolls* and Philia in *A Funny Thing Happened on the Way to the Forum*. She was known amongst her contemporaries as a dedicated, disciplined and studious pupil although Gaga claims that she often felt insecure, freakish and out of place in this religious and somewhat exclusive Upper East Side environment. Fellow pupils disputed this when worldwide fame hit and journalists came knocking for cheap stories, remembering her instead as popular with boys and already showing prowess in singing and performing with a highly original and artistic manner.

At the age of 17 Gaga so impressed examiners that she gained early admission to the New York University's Tisch School of the Arts and lived in a NYU dorm on 11th Street. There the embryonic Gaga studied music and improved her song-writing skills by composing essays and course papers focusing on topics as diverse as art, religion, social issues and politics. She also wrote a thesis on the pop artists Spencer Tunick and Damien Hirst. This broad level of knowledge and both taught and self-taught experience is evident in how she showcases her act today and came in useful for her future career focus in all areas of the media. Gaga's outstanding and highly original creative ability far outshone that of her classmates and she decided to quit by the second semester of her sophomore year to focus purely on music and performing. Her reluctant father agreed to pay her rent for a year on the condition that she re-enrolled at Tisch if music and the arts didn't work out.

GAGA HATCHES

Gaga was initially signed to Def Jam Recordings at the age of 19 but was then unceremoniously dumped by the label after just three months. Her former management company later arranged for her to meet the renowned and very-much-of-the-moment songwriter and producer, RedOne. The first collaboration with RedOne was 'Boys Boys Boys' an eclectic mix of sounds inspired by Mötley Crüe's 'Girls, Girls, Girls'. She moved into an apartment on the Lower East Side and recorded a couple of songs with hip-hop producer Grandmaster Melle Mel. She also started the Stefani Germanotta Band with a bunch of friends from NYU. They beavered away recording an EP collection of ballads at a studio underneath a dingy liquor store in New Jersey while at the same time becoming a regular local fixture on the downtown Lower East Side club scene. It was during this time that she began experimenting heavily with drugs (mainly cocaine) and performing at burlesque shows. She went onstage in a thong, lighting hairsprays on fire and go-go dancing to Black Sabbath with the club kids screaming and cheering her on. Her father, on seeing her act for the first time, was mortified and full of regret at his decision to allow Gaga to leave Tisch. He could see that her branching out on her own had provided quite jaw-dropping results and could also recognize her focus and drive, but at what cost? He found her drug use utterly shocking and would not speak to her for several months.

It was around this time that the name Lady Gaga came into being. Music producer Rob Fusari, who helped her write some of the early songs, would start singing 'Radio Ga Ga' every time she walked into the studio. One day he sent her a text but his phone's predictive text function changed 'Radio Ga Ga' to 'Lady Gaga' and a legend was born. The newly titled Lady Gaga announced that there was no way she ever wanted to be called Stefani again and that only Gaga would do. If you were going to call her Stefani she simply didn't want to know.

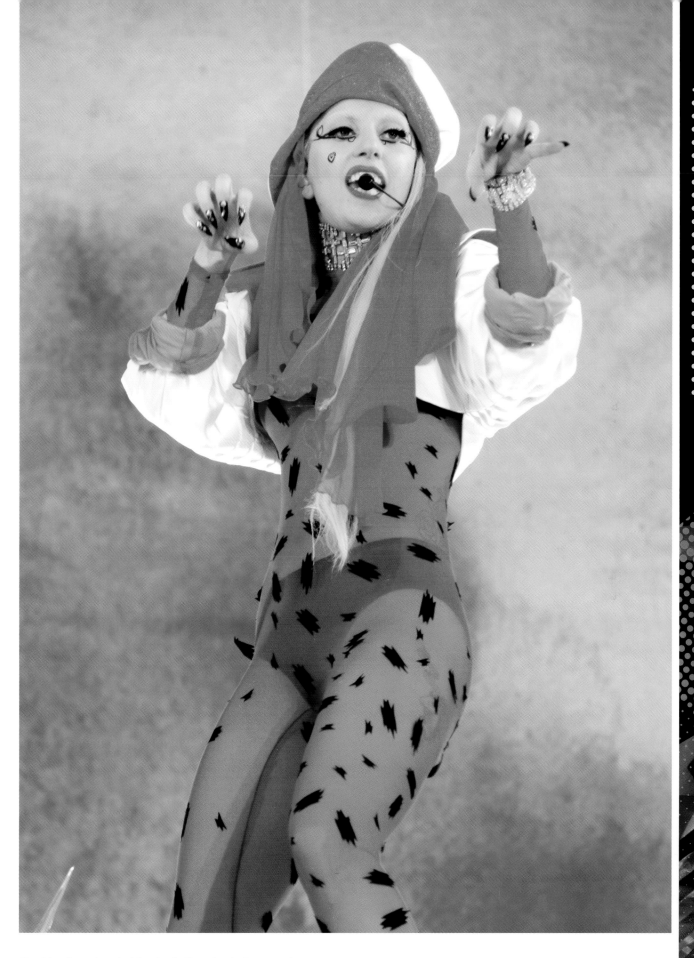

Fetching in red and white, Lady G enthrals the crowd.

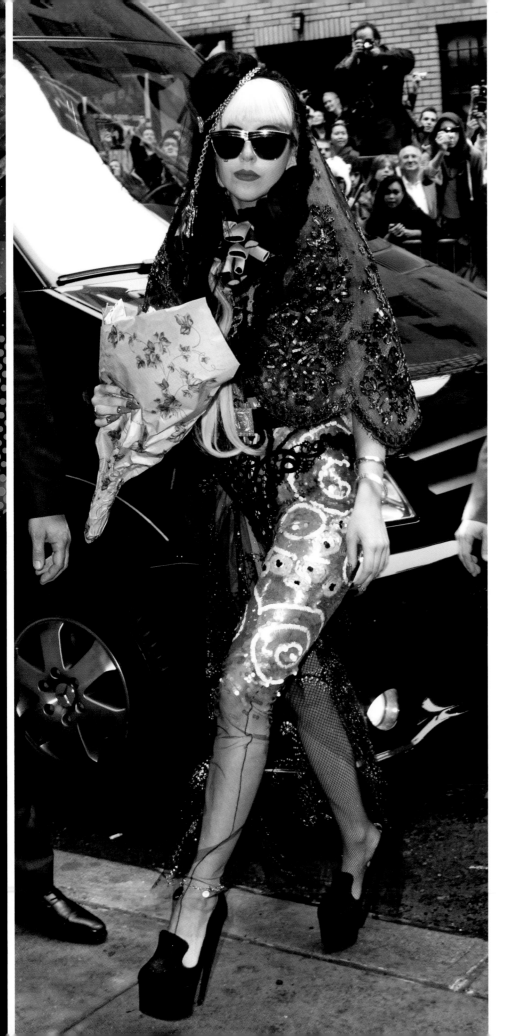

LADY GAGA STYLE BIBLE

Funeral attire or just a trip to store? Actually she was on her way to the David Letterman show but either way Lady G mixes and matches to the max!

Throughout 2007 Gaga collaborated with the outrageous performance artist Lady Starlight. They experimented with the creation of lurid but essentially harmless fashions to enhance their act. The fame-hungry pair began putting on performances at grungy downtown club venues like the Mercury Lounge and The Bitter End to a sometimes bemused and vaguely hostile crowd of college kids while at the same time starting a buzz in what was a ferociously competitive scene. Their live performances were essentially art pieces or happenings and went under the moniker of 'Lady Gaga and the Starlight Revue'. In August of 2007, Gaga and Starlight were beyond excited to be invited to play at the legendary American Lollapalooza music festival. This iconic show was critically acclaimed not just in the USA but all over the world by music and media watchers. Gaga and Starlight rehearsed into the early hours for weeks on end and the effort paid off as their performance received glowing reviews for being extremely cutting edge in what was a visual media savvy yet easily jaded audience.

Originally Gaga focused musically on avant-garde electronic dance music but she found her musical *oeuvre* when she began to use simple pop melodies and combine them with the glam rock panache of David Bowie and Queen. Fusari sent the songs he produced with Gaga to his friend, the producer and record executive Vincent Herbert. Herbert was desperate to sign her to his label Streamline Records, an imprint of Interscope Records, Gaga's current label. During this time she also served as an apprentice songwriter under a much sought after internship at Famous Music Publishing. As a result she started to write for a wide circle of acts including Britney Spears, the reformed New Kids on the Block and Fergie; she would later tour with NKOTB and the Pussycat Dolls. While Gaga was branching out into providing songs for a host of other acts she met singer-songwriter Akon who recognized her underused vocal abilities when he heard her sing a vocal for one of his tracks. Akon went on to persuade Interscope-Geffen-A&M Chairman and CEO Jimmy Iovine to form a joint deal by having her sign with his own label Kon Live Distribution which lead to her being taken seriously in the music industry.

GAGA FLIES

In 2008 Gaga decided to relocate to Los Angeles while finishing her debut album *The Fame*. The album is a mix of different genres complementing all areas of modern pop. It soars with futuristic electro beats and canny nods to retro rock at its best and led to six single releases (a later extended edition called *Fame Monster* had 'Bad Romance', 'Alejandro' and 'Telephone' included on it). *The Fame* received significant positive reviews from music critics around the world, although Europe and the UK in particular went crazy for its dirty underground beats and disco-fuelled highlights. The album peaked at number one in the UK, Canada, Austria, Germany, Switzerland and Ireland, and made the top-five in Australia, the United States and 15 other countries. Worldwide, *The Fame* has now sold over 14 million copies. The lead single 'Just Dance' raced to the top of the charts in six countries – Australia, Canada, the Netherlands, Ireland, the United Kingdom and the United States – and later received a Grammy Award nomination for Best Dance Recording.

The video itself was one on the first signs for fans and media watchers alike had of just how powerful Gaga was going to be, with her use of visuals in what was already a highly established and over-saturated YouTube age. Think *My So-Called Life* meets 1970s suburban Detroit pastiche decor and you're not far wrong. The total sense of fun with a capital F is brought to the fore via slightly kinky goings-on with a PVC killer whale, abundant zebra print, a truly 80s shoulder-pad entrance, a smattering of leopard print, barely-there lesbian-lite frisson and rapper Colby Denis just a little bit too cool for school in the corner. All of these vignettes frame the ideas of someone who definitely has a true understanding of what makes a killer pop tune.

The second single 'Poker Face' was an even bigger success, reaching number one in almost all the world's major music markets and once again securing the top slot in the UK and US. It went on to win the award for Best Dance Recording at the 52nd Grammy Awards, at which she arrived in an outfit that made Jane Fonda's *Barbarella* look like background scenery from Star Trek.

Gaga again hit the video jackpot and delighted her Little Monsters with a slightly smoother and altogether slicker promo. The clip starts with a dripping wet, futuristic black-PVC-clad Gaga emerging from a pool, sporting a mirrored skull cap. Two rather impressive Great Danes look on nonchalantly as a sort of Bladerunner mash-up takes place in the poolside arena. Lashings of diamond rings, buff dancers, nails to die for and a Donatella Versace-esque transformation into a bathing suit goddess unfolds as our sainted Lady of Gaga moves on to the adoration of nervous-looking yet sexy godlike boy/man. All of this, plus a few poker

tips and a useful suggestion if you happen to pick up a muffin to go with your morning coffee. This truly got the new MTV generation flushed with excitement.

Although her first concert tours were as a support act for the re-cobbled New Kids on the Block and the Pussycat Dolls she soon headlined her own worldwide concert tour. The Fame Ball Tour began in March 2009 and lasted for six months, garnering worldwide critical acclaim. More than an average stadium tour, this was Gaga channelling the spirit of Warhol for the masses. It was a high octane mix of performance art, multimedia visuals and extreme fashion creating ultimate experience for not only Gaga fans but music lovers everywhere. Gaga had wanted the tour to be a non-stop travelling carnival with something for everyone and she really pulled it off. Rarely has another artist managed a grand slam like this with the experience of just one album and performances as a touring support act under their belt. One of the major highlights was the groundbreaking array of outfits and multiple costume changes, including a dress made from plastic bubbles, video sunglasses, a barely-there hot black and white leotard with pointed puff shoulders and, to top it all off, a hat made of toppled dominos.

In the same year she graced the cover of the annual 'Hot 100' issue of *Rolling Stone*; a semi-nude Gaga worked the 'strategically-placed plastic bubbles look' again to her advantage. She was also nominated for nine awards at the 2009 MTV Video Music Awards, winning the award for Best New Artist, and the single 'Paparazzi' won two awards for Best Art Direction and Best Special Effects. Paparazzi was her most extravagant piece of video work so far. Directed by Jonus Akerlund and co-starring hunk of the month Alexander Skarsgard from True Blood, this mini-movie deals with the nature of the fame that Gaga now had to deal with, albeit with a healthy dose of irony. Dior accessories sparkle throughout and even Gaga's wheelchair gets a makeover. Gaga money abounds (Madonna did the same on her 1985 'Like a Virgin' tour) and there are even subtitles for the culturally inclined. Think Ingmar Bergman meets *The OC* and you've just about hit the spot. In October she also received *Billboard* magazine's 'Rising Star of 2009' award.

THIS IS THE HAUS THAT GAGA BUILT

Gaga couldn't do any of the amazing and outlandish things she does without her amazing creative team. Christened 'The Haus of Gaga', the team is modelled very much on Andy Warhol's 'Factory' and aspires to keep to that ethic 24/7. The team work tirelessly behind the scenes to follow Gaga's directions on stage sets, props and almost every angle of her stage performance. The members have included Matthew Williams, Laurie Ann Gibson and Nicola Formichetti along with dancers and occasional honoury members so it's a never-ending eclectic mix of people helping Gaga realize her dreams. After the debut album's success Gaga decided to release *The Fame Monster* artwork visuals with her look echoing the Daryl Hannah character Pris from *Bladerunner*. This version contained a bonus disc of eight new songs. The brand new tracks tapped into the seedy underbelly issues of global fame from the personal perspective of an artist that was at the white hot centre of it all at the time.

The lead single 'Bad Romance' skyrocketed to the top of the charts in 18 different countries while also securing the number two position in the USA. Gaga also became the first music artist in digital history to have three singles (including 'Just Dance' and 'Poker Face') to exceed the four million mark in digital download sales.

'Bad Romance' was up next and it won a Grammy for Best Female Pop Vocal Performance while the video again propelled Gaga to new heights of music video history. *Alien* versus Japanese anime were the token nods for this mini-classic. A pair of amazing McQueen heels along with lingerie raised to new ultra-sexy heights showcased a Gaga with all guns blazing as she fought off an army of terrifyingly temperamental models. The video climaxes with some unfortunate chap being cremated via nipple tassel (although he merely looks somewhat indifferent and grumpy throughout). This mini masterpiece won the Grammy Award for 'Best Short Form Music Video'.

The second single 'Telephone', a duet with Beyoncé Knowles, was nominated for the Grammy Award for Best Pop Collaboration with Vocals and also became Gaga's fourth UK number-one single. The video generated a healthy amount of controversy and was probably one of Gaga's most ambitious projects so far. Beyoncé plays up to all of Gaga's highjinks perfectly and you get a real sense that this is a meeting of minds between the two artists. The video runs at just over nine minutes long and is played out as a film short with opening and closing credits. The ante is upped with the now iconic smoking glasses, a more than healthy smattering of lesbian-lite, an even healthier dose of product placement; from the cultural reference point of view think Madonna's look in 'Who's that Girl' running alongside a 'Thelma and

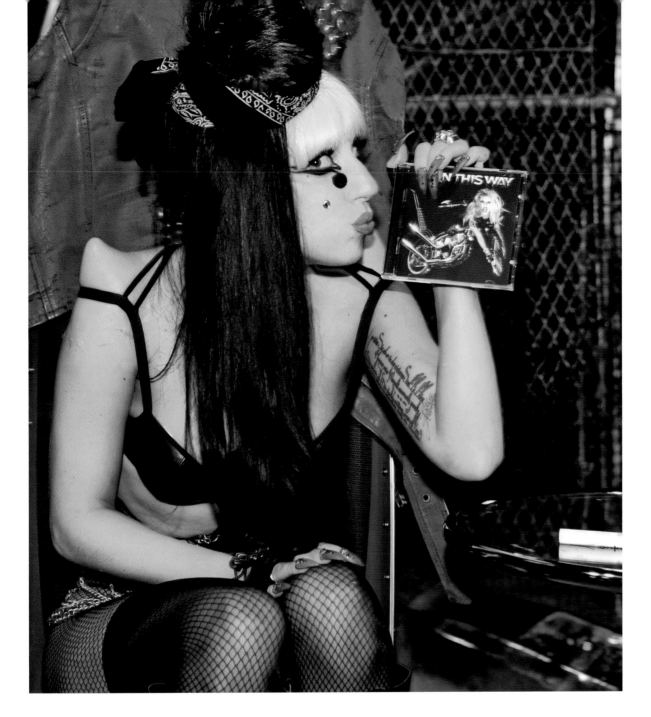

Kiss Kiss! Gaga Cosies up at an in store appearance in NYC.

Louise' sub-plot. The truly scandalous use of crime scene tape would have pleased dads everywhere who happened to be checking up on their little darlings' cookies. This truly was one for all the family...

Next up was 'Alejandro'. In video form this helped Gaga to work with the amazing high-end fashion photographer Steven Klein. Just as controversial as 'Telephone', but this time dark in the extreme and generously blasphemous to keep the Catholic Church busy this was perhaps Gaga's most knowing nod to Madonna. Almost as long as 'Telephone' and a sublime mix of the films 'The Night

Porter' and 'Metropolis', the controversy around the video no doubt contributed to Gaga being the first artist to gain over one billion viral views on YouTube. The 'Fame Monster' album went on to win 'Best Pop Vocal Album'.

The global success of the album pushed Gaga onwards to embark on her second headlining worldwide concert tour – the aptly named 'The Monster Ball Tour' – to support the 'Fame Monster' release. This exquisitely detailed and truly accomplished visual extravaganza toured the world continuously for over 18 months. Earlier Gaga had intended to do a joint

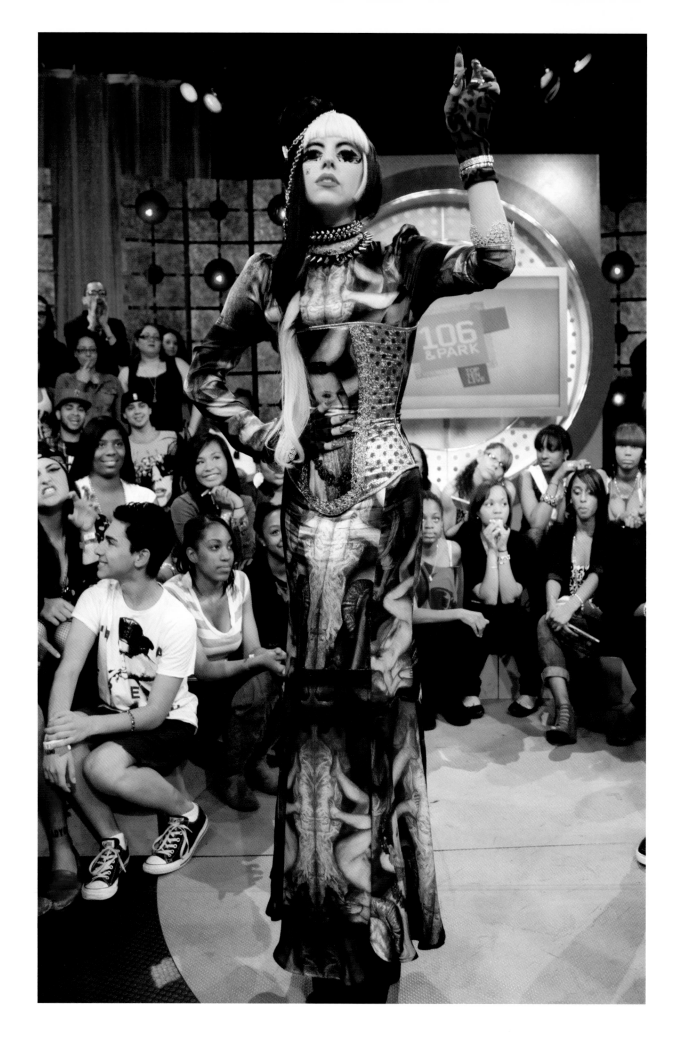

tour with Kanye West but such a momentous meeting of sounds and styles was not to be. Instead she devised a tour around the theme of her own evolution and the personal growth she felt she had gone through in such a short space of time. The groundbreaking show was divided into five parts and involved a plot of sorts featuring Lady G and assorted friends lost in New York but desperately trying to find the 'Monster Ball'. Critics heaped praise on the show and special attention was paid to the strength of Gaga's live vocal performance as compared to the number of performers who regularly lip synched, as well as the amazing array of costumes that she had once again dazzled the world with.

BORN TO RUN AND RUN

Gaga's second studio album and third major release *Born This Way* was released in May 2011 following the groundbreaking lead single of the same name. Again, the video reached near mythic proportions. Rooted firmly within 1970s and '80s filmic traditions, the video opens with a chilling message from Mother Monster announcing the birth of good and evil in outer space. A kaleidoscope of images plays out with a space age crucifix and Mexican death masks thrown into the mix along with overriding message of self empowerment in believing and accepting who you are.

Gaga performed the single live for the first time at the 53rd Grammy Awards. More, however, was made of her entrance; she was carried by futuristic models along the red carpet in a gigantic embryo-shaped incubator (called 'The Vessel' by its designer, Hussein Chalayan) complete with fan and oxygen supply, and there she stayed until her (much later) performance, hatching onstage.

So what does the future hold now for Gaga? Reviews for the *Born this Way* album exceeded all expectations and the video's for the first two singles, 'Born this Way' and 'Judas', drawing just as much attention as their predecessors. The video for 'Judas' was yet again a high octane mix of biker chic, a liberal take on biblical themes and around eleven costume changes from Gaga while she channelled the spirit of Mary Magdalene.

Earlier this year she wowed Carlisle in the UK and outdid herself again by emerging from a gold coffin. Sporting a black PVC and rubber number with fake pregnancy bump Gaga belted out 'Born this Way' only to then discard her bump, revealing a rubber crop top, to carry on and perform three of her biggest hits. Who else shows this ultimate commitment to keeping their fans entertained, to the team that work with them and the concept of art in general? Lady Gaga is a true artist leaving no medium unexplored. Just as she showed with the meat dress in LA, Gaga is more than music and more than mere style. She is a true original and this is only the beginning of the making of an icon.

Strike a pose! Our Lady of Gaga at BET studios in May 2011.

ATTENTION TO DETAIL

LADY GAGA STYLE BIBLE

16

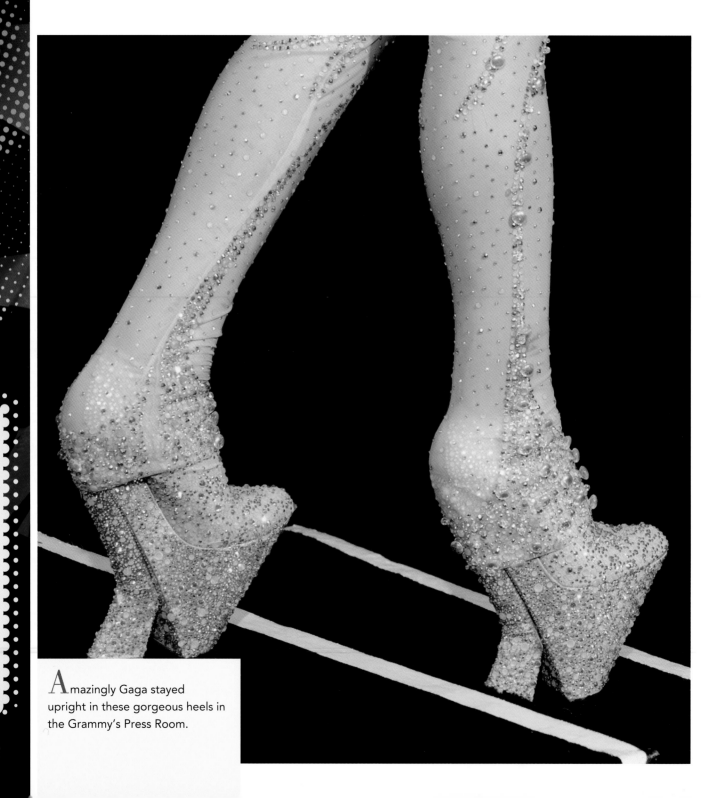

Amazingly Gaga stayed upright in these gorgeous heels in the Grammy's Press Room.

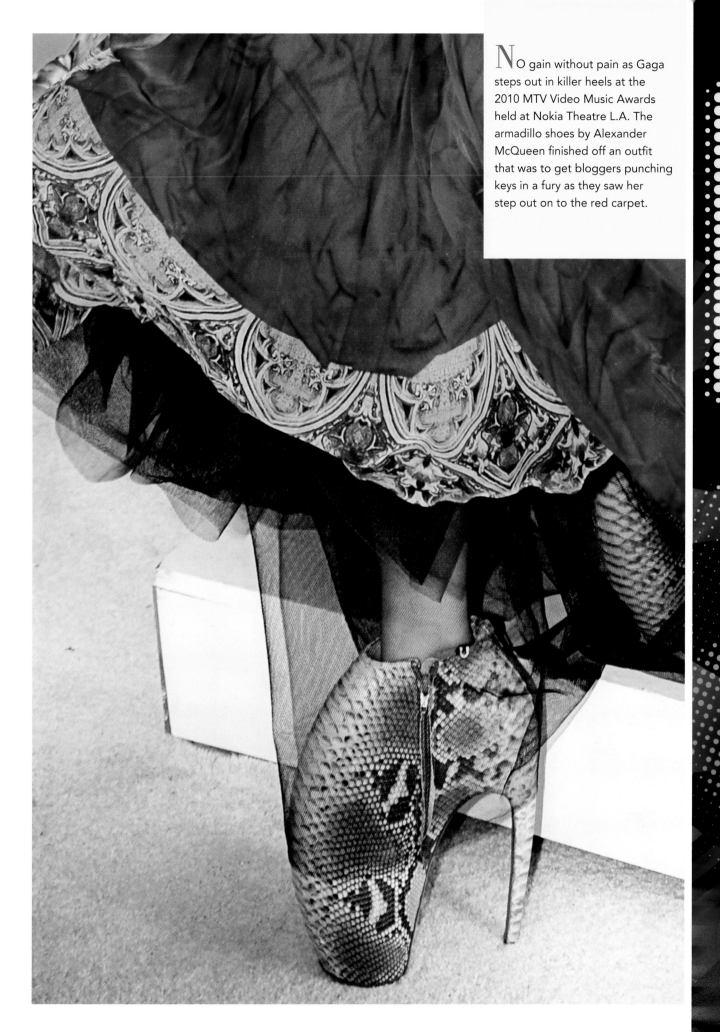

No gain without pain as Gaga steps out in killer heels at the 2010 MTV Video Music Awards held at Nokia Theatre L.A. The armadillo shoes by Alexander McQueen finished off an outfit that was to get bloggers punching keys in a fury as they saw her step out on to the red carpet.

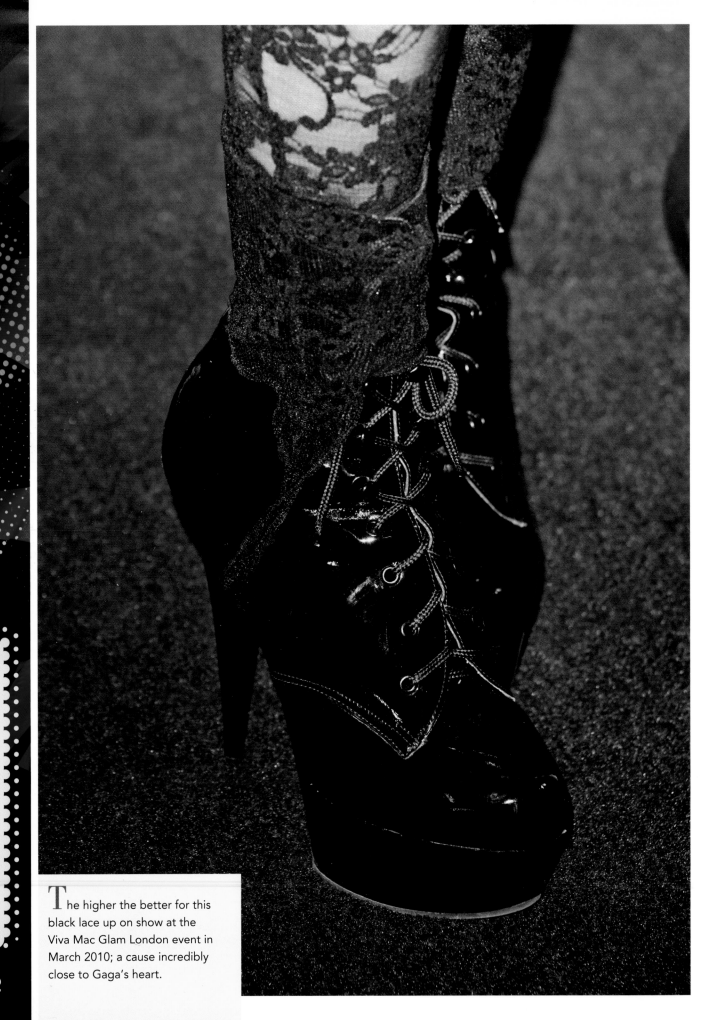

The higher the better for this black lace up on show at the Viva Mac Glam London event in March 2010; a cause incredibly close to Gaga's heart.

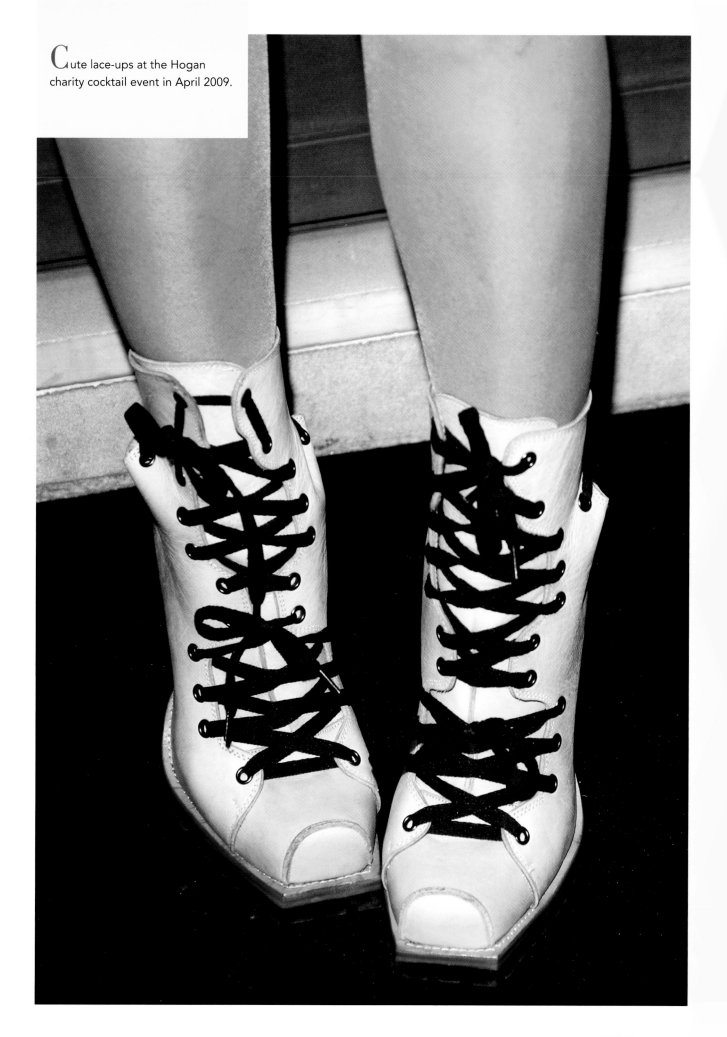

Cute lace-ups at the Hogan charity cocktail event in April 2009.

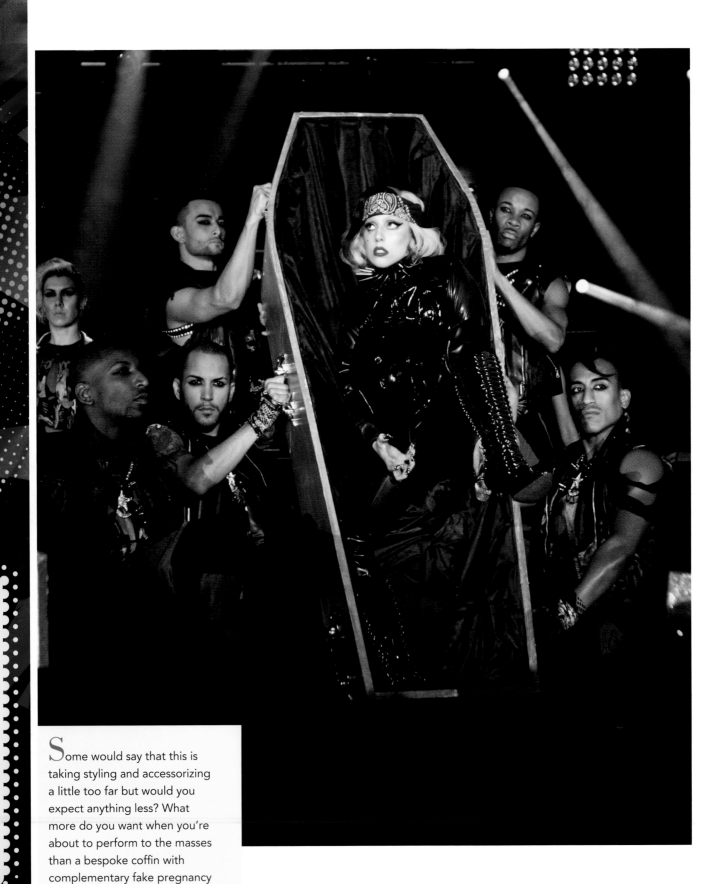

Some would say that this is taking styling and accessorizing a little too far but would you expect anything less? What more do you want when you're about to perform to the masses than a bespoke coffin with complementary fake pregnancy bump? Something for all the family...

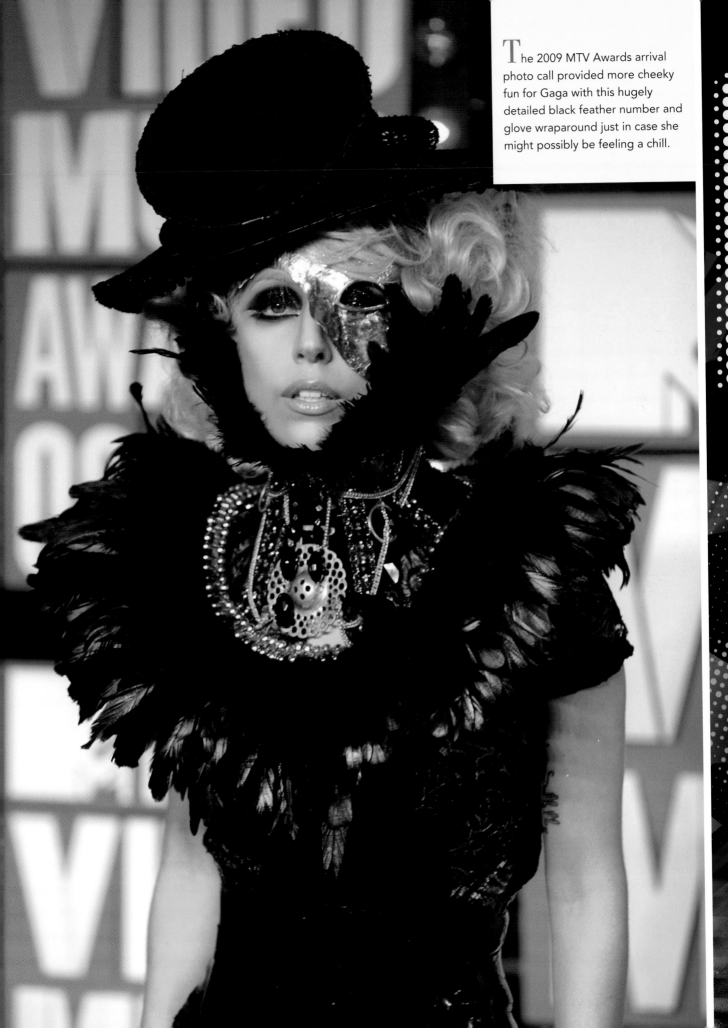

The 2009 MTV Awards arrival photo call provided more cheeky fun for Gaga with this hugely detailed black feather number and glove wraparound just in case she might possibly be feeling a chill.

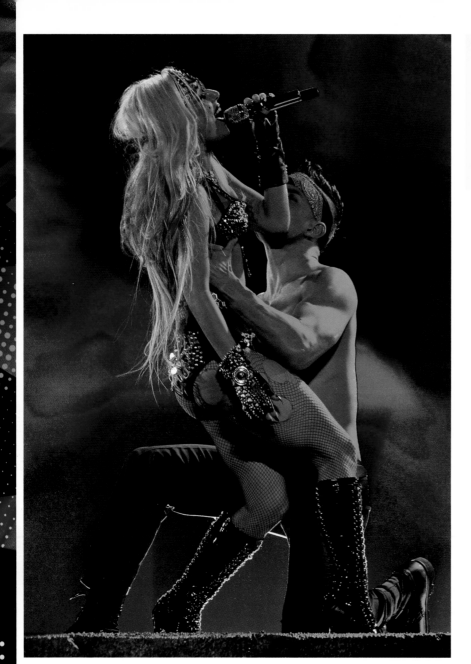

Always good to match your gloves and boots and Gaga is no exception to the trend while she performs on American Idol.

No detail is spared by the first lady of popular music; her fingerless PVC gloves showcase talons to die for. Gaga was on a fairly low-key outing while arriving on Broadway but as usual was dressed to the max.

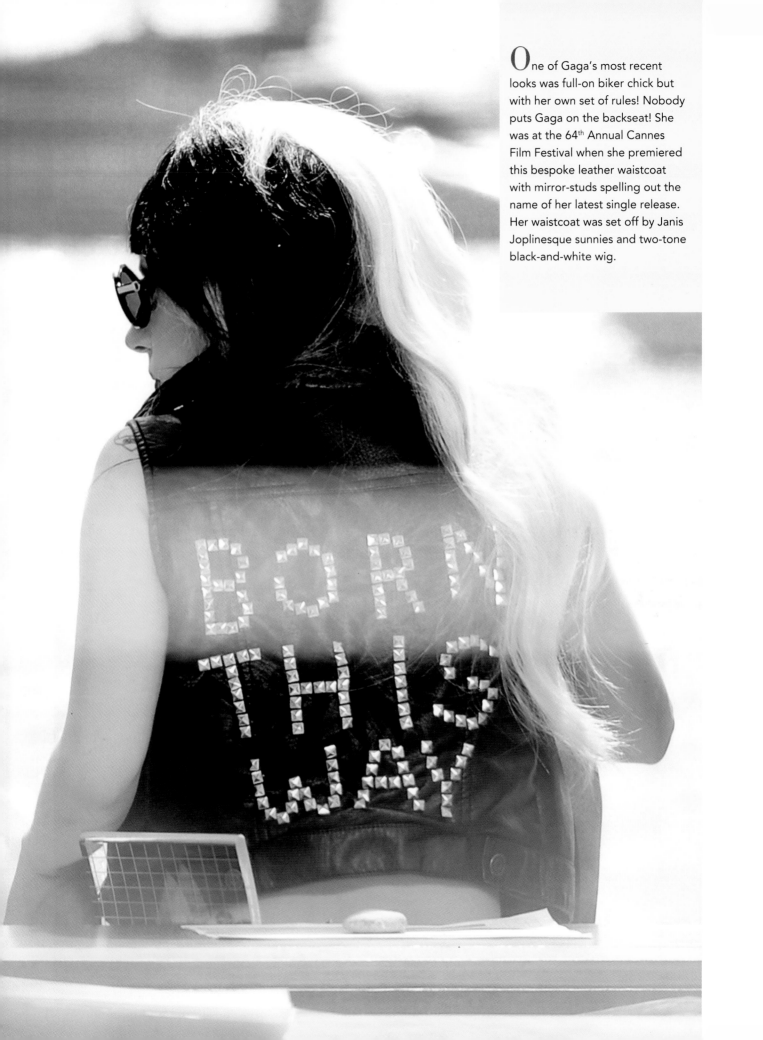

One of Gaga's most recent looks was full-on biker chick but with her own set of rules! Nobody puts Gaga on the backseat! She was at the 64th Annual Cannes Film Festival when she premiered this bespoke leather waistcoat with mirror-studs spelling out the name of her latest single release. Her waistcoat was set off by Janis Joplinesque sunnies and two-tone black-and-white wig.

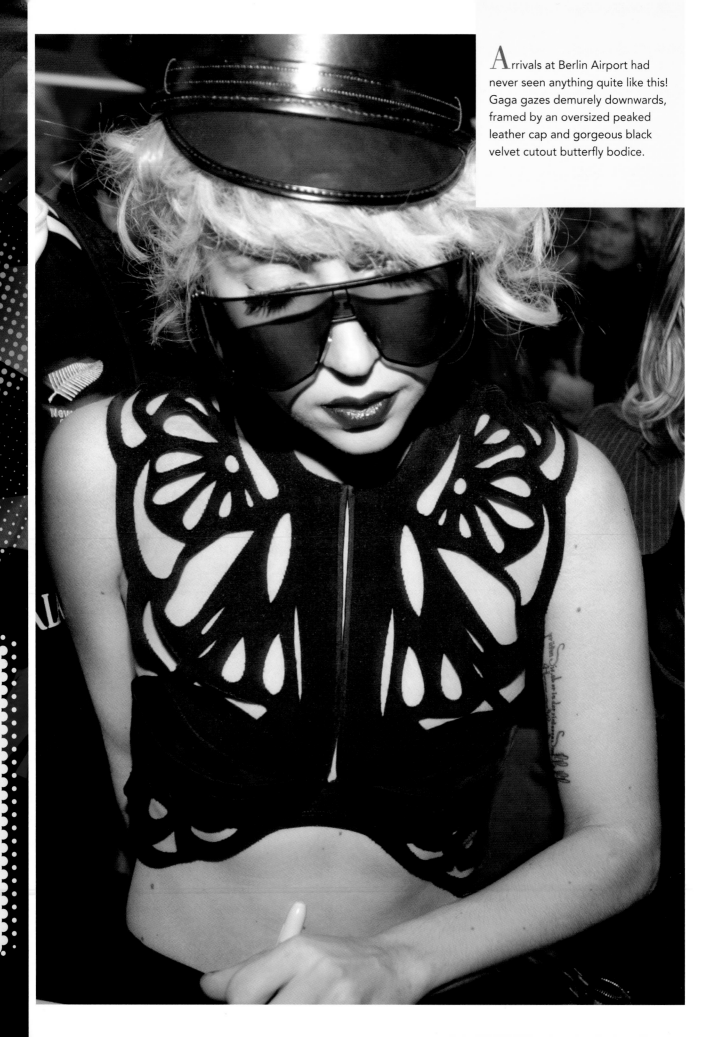

Arrivals at Berlin Airport had never seen anything quite like this! Gaga gazes demurely downwards, framed by an oversized peaked leather cap and gorgeous black velvet cutout butterfly bodice.

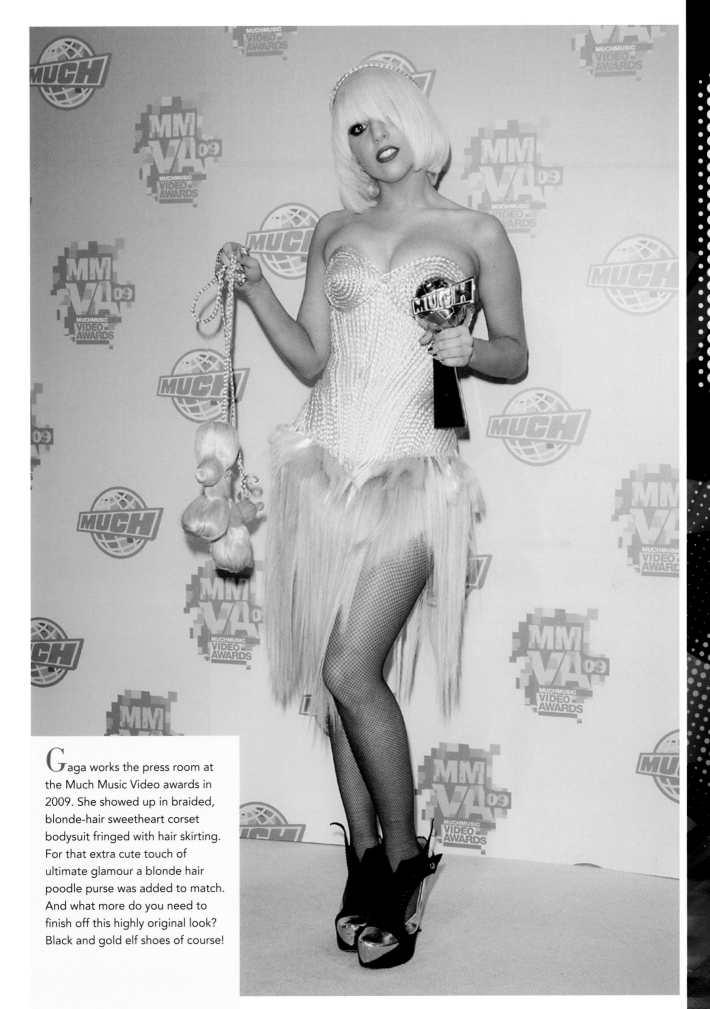

Gaga works the press room at the Much Music Video awards in 2009. She showed up in braided, blonde-hair sweetheart corset bodysuit fringed with hair skirting. For that extra cute touch of ultimate glamour a blonde hair poodle purse was added to match. And what more do you need to finish off this highly original look? Black and gold elf shoes of course!

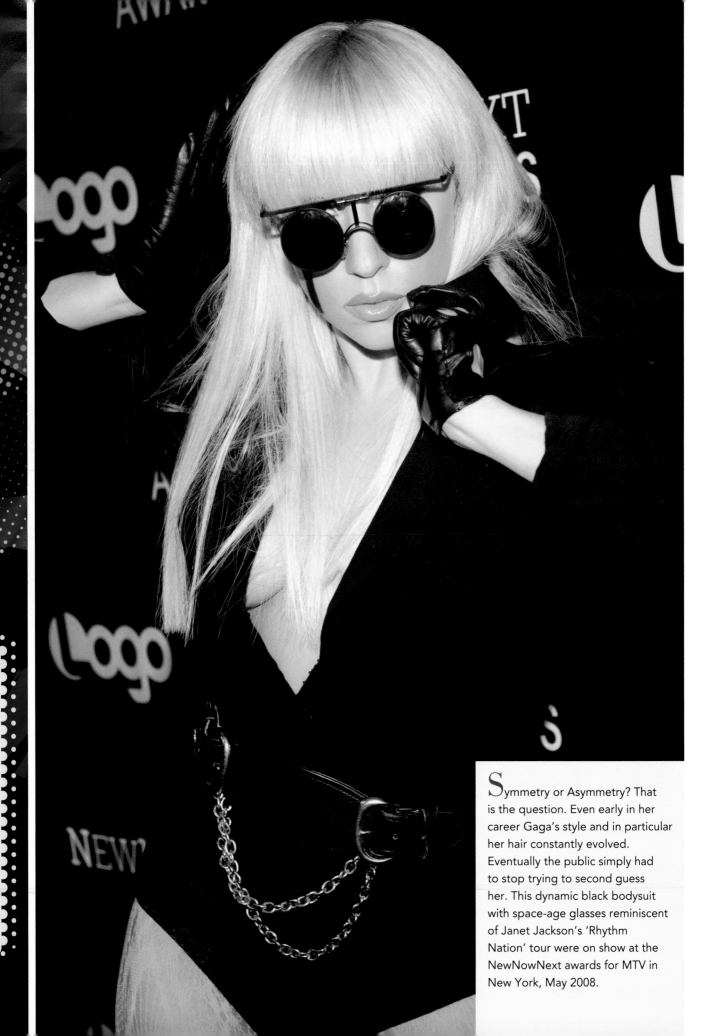

Symmetry or Asymmetry? That is the question. Even early in her career Gaga's style and in particular her hair constantly evolved. Eventually the public simply had to stop trying to second guess her. This dynamic black bodysuit with space-age glasses reminiscent of Janet Jackson's 'Rhythm Nation' tour were on show at the NewNowNext awards for MTV in New York, May 2008.

BLONDE AMBITION

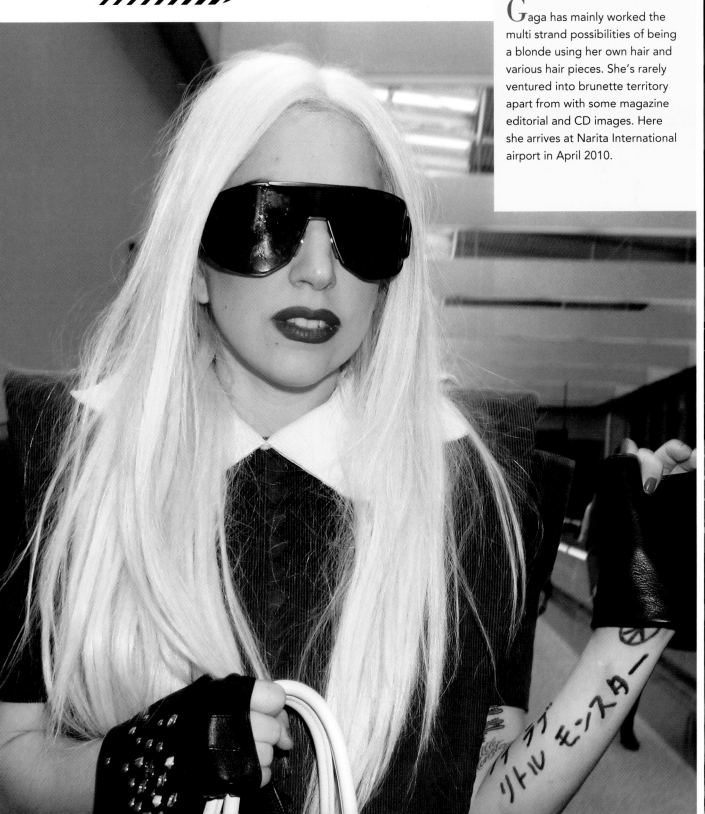

Gaga has mainly worked the multi strand possibilities of being a blonde using her own hair and various hair pieces. She's rarely ventured into brunette territory apart from with some magazine editorial and CD images. Here she arrives at Narita International airport in April 2010.

CUTTING-EDGE CASUAL

Gaga hit the town in London in 2010 much to the paparazzi's delight. Although somewhat serious in pose one gets the impression it's all for fun with the UK media watching her every move. Although this is classic twist on an androgynous but beautifully tailored look, Gaga is also giving a nod to one of her all-time idols and now close friend, Cyndi Lauper.

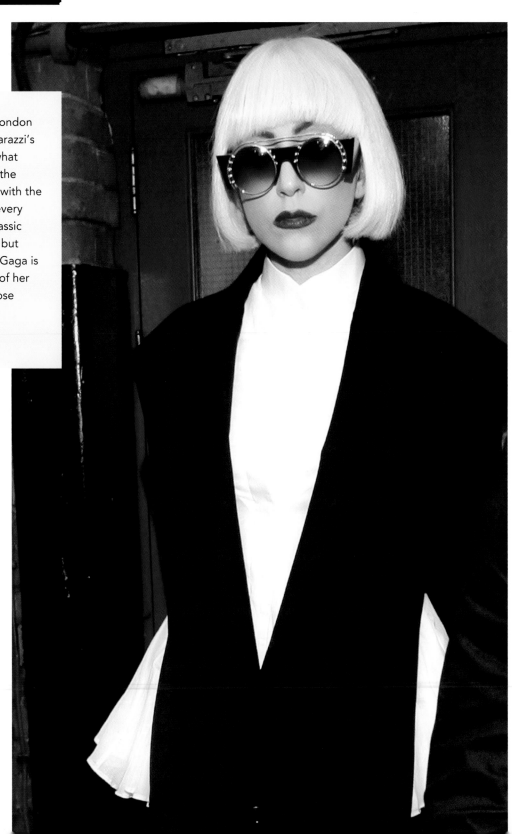

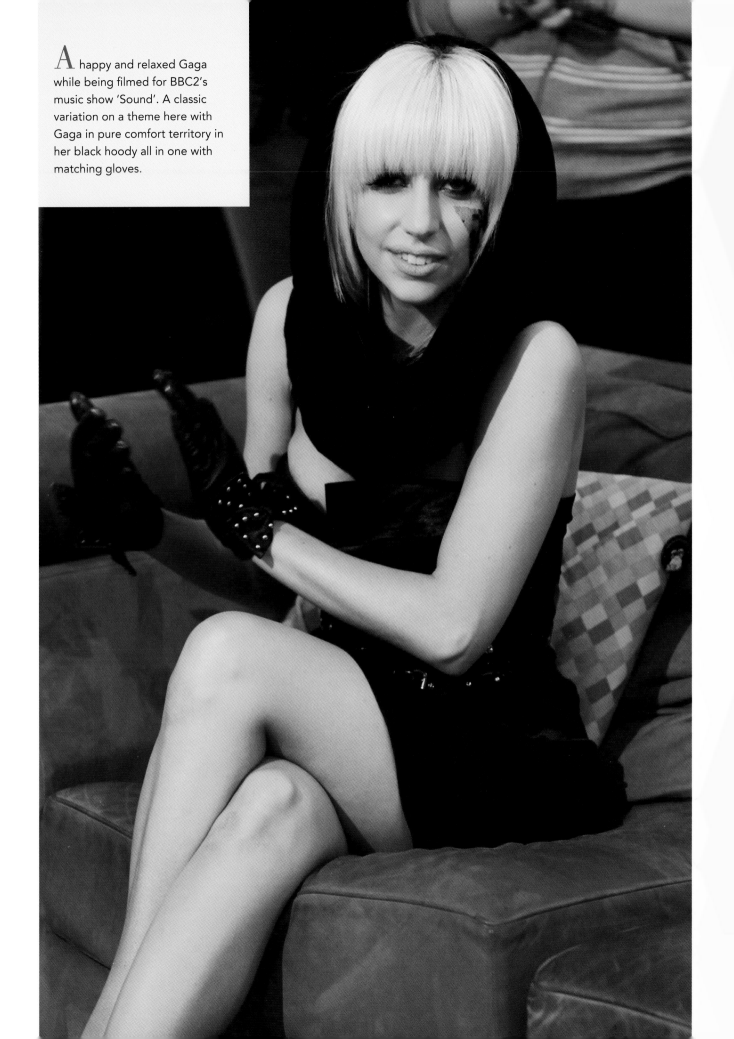

A happy and relaxed Gaga while being filmed for BBC2's music show 'Sound'. A classic variation on a theme here with Gaga in pure comfort territory in her black hoody all in one with matching gloves.

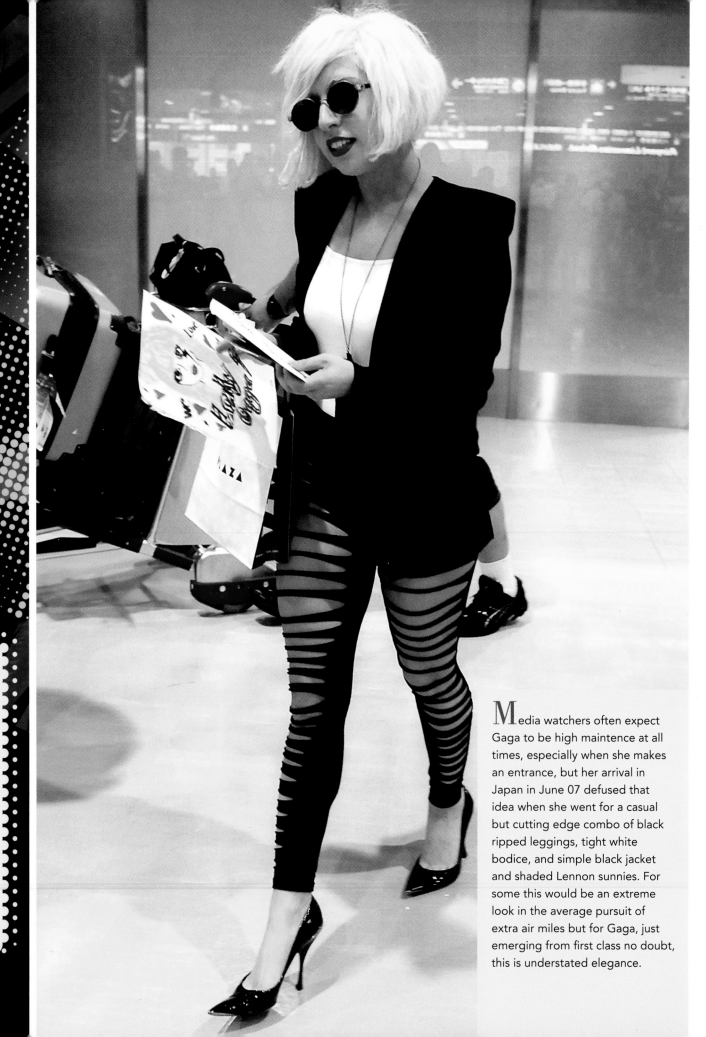

Media watchers often expect Gaga to be high maintence at all times, especially when she makes an entrance, but her arrival in Japan in June 07 defused that idea when she went for a casual but cutting edge combo of black ripped leggings, tight white bodice, and simple black jacket and shaded Lennon sunnies. For some this would be an extreme look in the average pursuit of extra air miles but for Gaga, just emerging from first class no doubt, this is understated elegance.

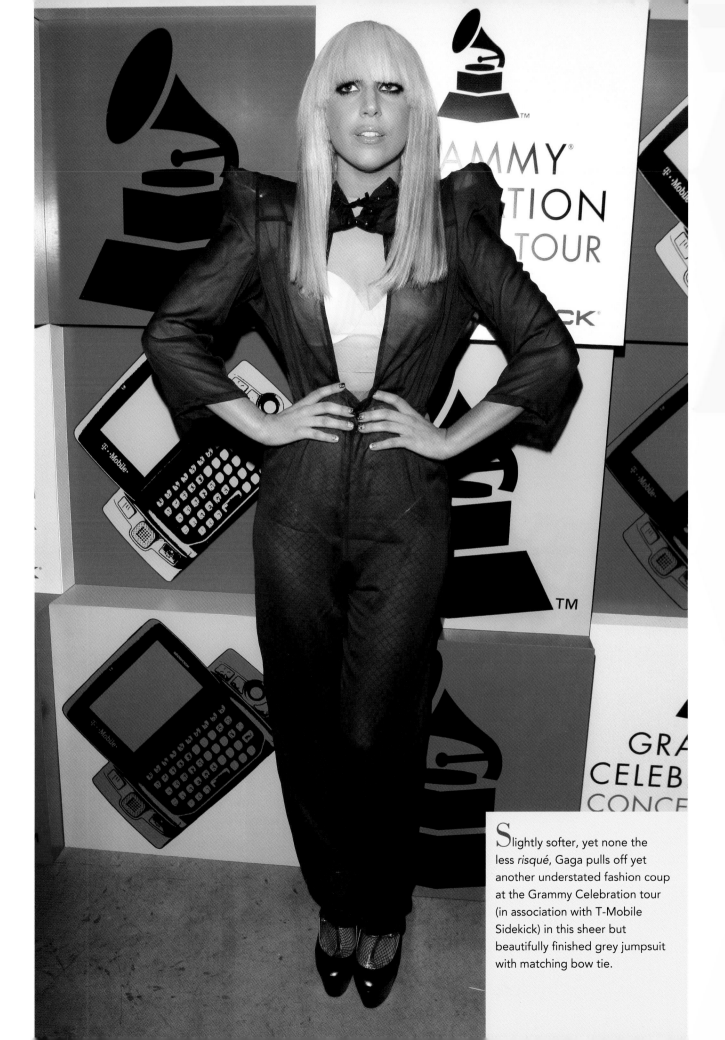

Slightly softer, yet none the less *risqué*, Gaga pulls off yet another understated fashion coup at the Grammy Celebration tour (in association with T-Mobile Sidekick) in this sheer but beautifully finished grey jumpsuit with matching bow tie.

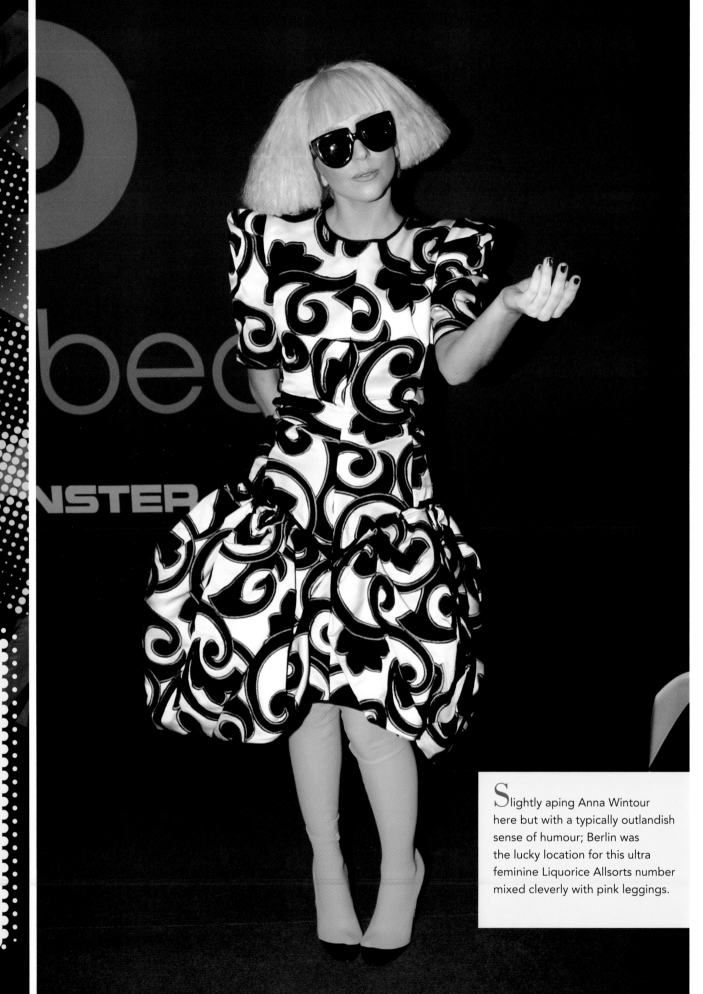

Slightly aping Anna Wintour here but with a typically outlandish sense of humour; Berlin was the lucky location for this ultra feminine Liquorice Allsorts number mixed cleverly with pink leggings.

DANGEROUS DAYS

Never afraid to court controversy, least of all with the Catholic church, Gaga gives a knowingly comedic turn with this wash-and-wipe see-through all-in-one bodysuit complemented by a white extended habit. All high-octane performers need a mouthpiece like this to create the kind of dance-led shows Gaga performs.

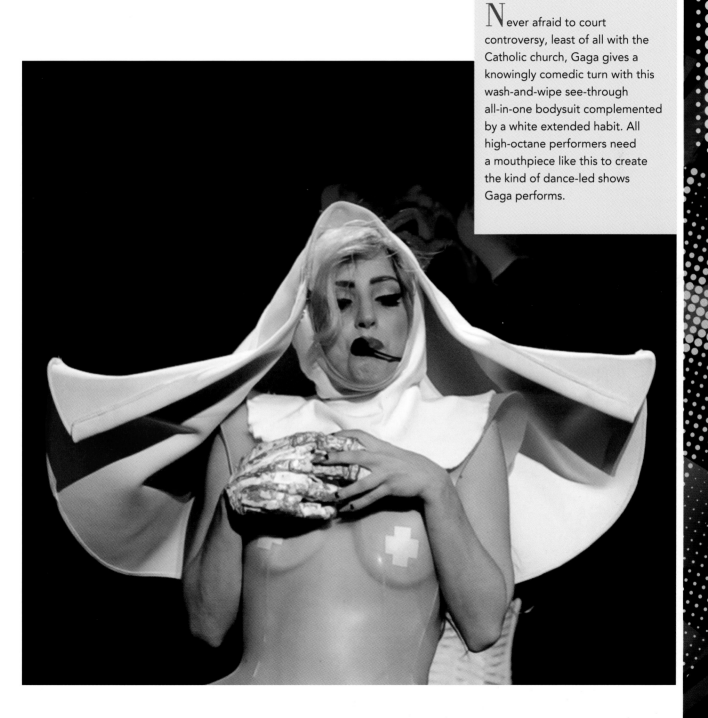

EGG
CENTRIC

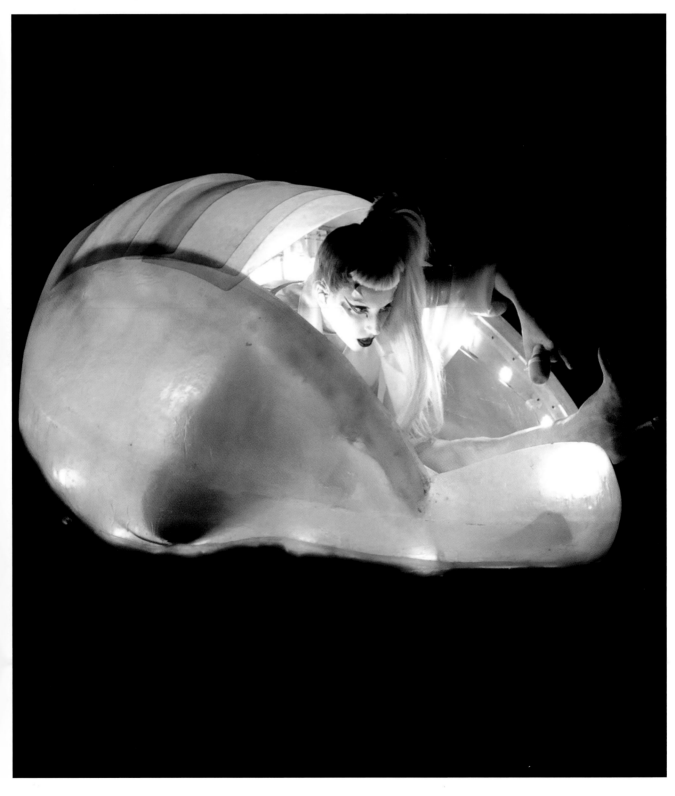

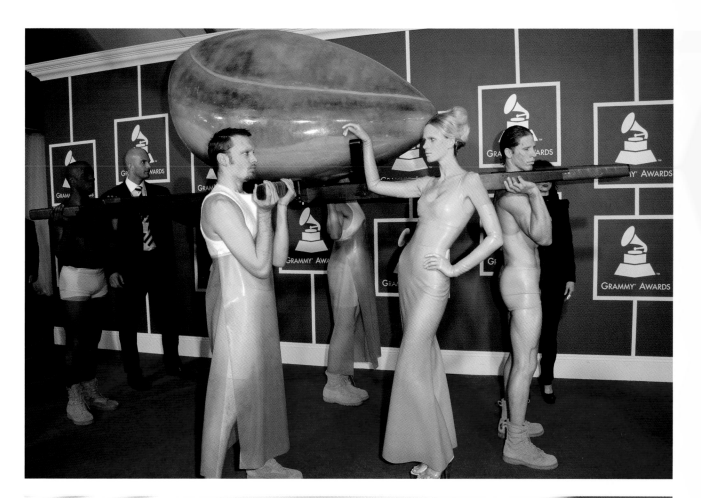

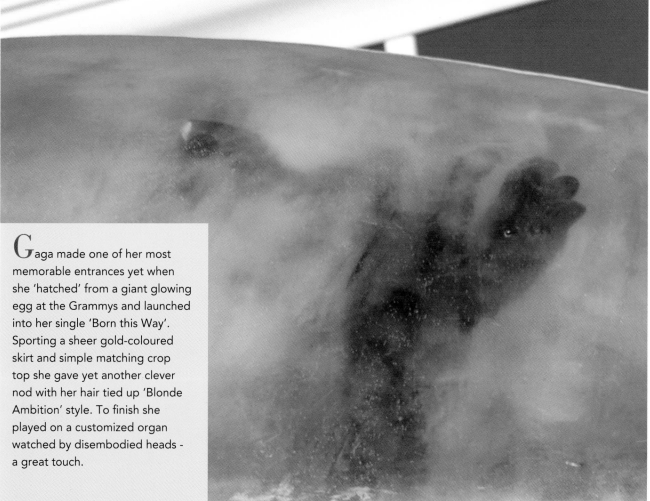

Gaga made one of her most memorable entrances yet when she 'hatched' from a giant glowing egg at the Grammys and launched into her single 'Born this Way'. Sporting a sheer gold-coloured skirt and simple matching crop top she gave yet another clever nod with her hair tied up 'Blonde Ambition' style. To finish she played on a customized organ watched by disembodied heads - a great touch.

FEMININE
FANTASTIC

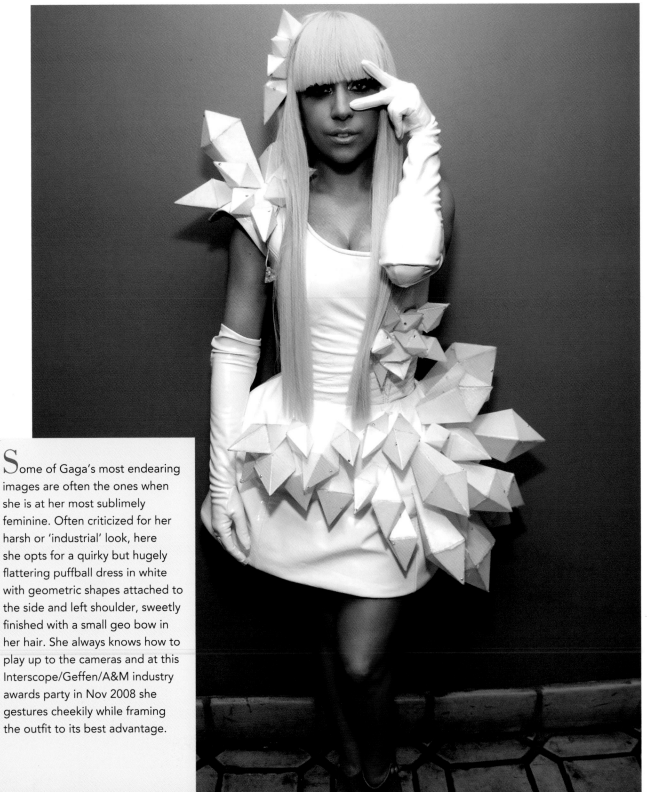

Some of Gaga's most endearing images are often the ones when she is at her most sublimely feminine. Often criticized for her harsh or 'industrial' look, here she opts for a quirky but hugely flattering puffball dress in white with geometric shapes attached to the side and left shoulder, sweetly finished with a small geo bow in her hair. She always knows how to play up to the cameras and at this Interscope/Geffen/A&M industry awards party in Nov 2008 she gestures cheekily while framing the outfit to its best advantage.

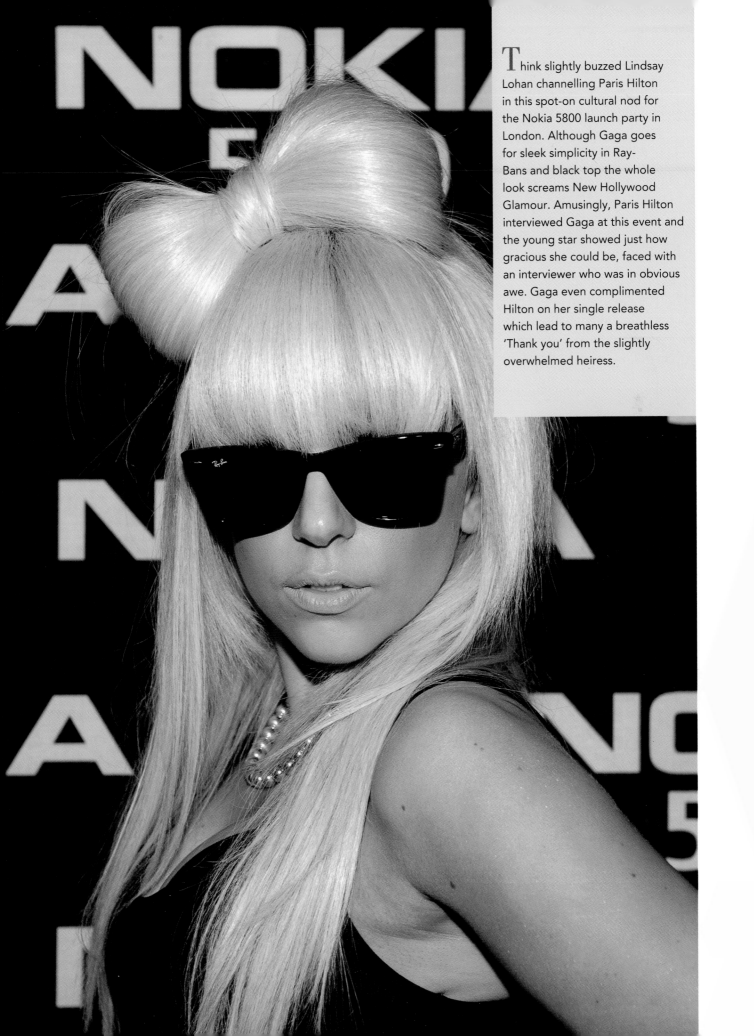

Think slightly buzzed Lindsay Lohan channelling Paris Hilton in this spot-on cultural nod for the Nokia 5800 launch party in London. Although Gaga goes for sleek simplicity in Ray-Bans and black top the whole look screams New Hollywood Glamour. Amusingly, Paris Hilton interviewed Gaga at this event and the young star showed just how gracious she could be, faced with an interviewer who was in obvious awe. Gaga even complimented Hilton on her single release which lead to many a breathless 'Thank you' from the slightly overwhelmed heiress.

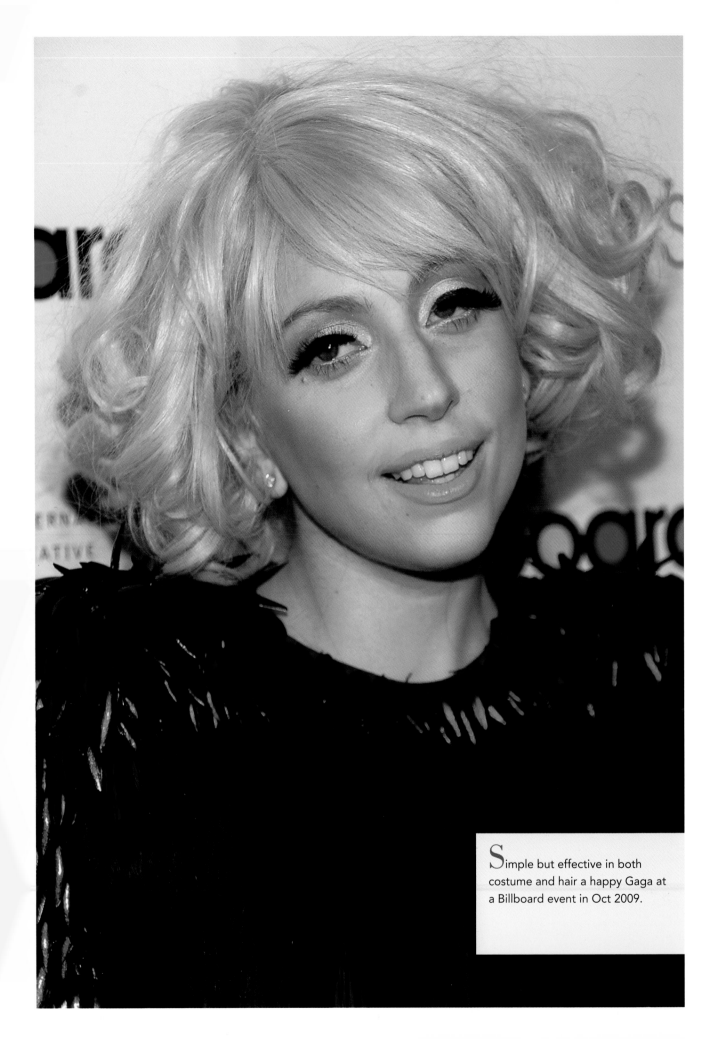

Simple but effective in both costume and hair a happy Gaga at a Billboard event in Oct 2009.

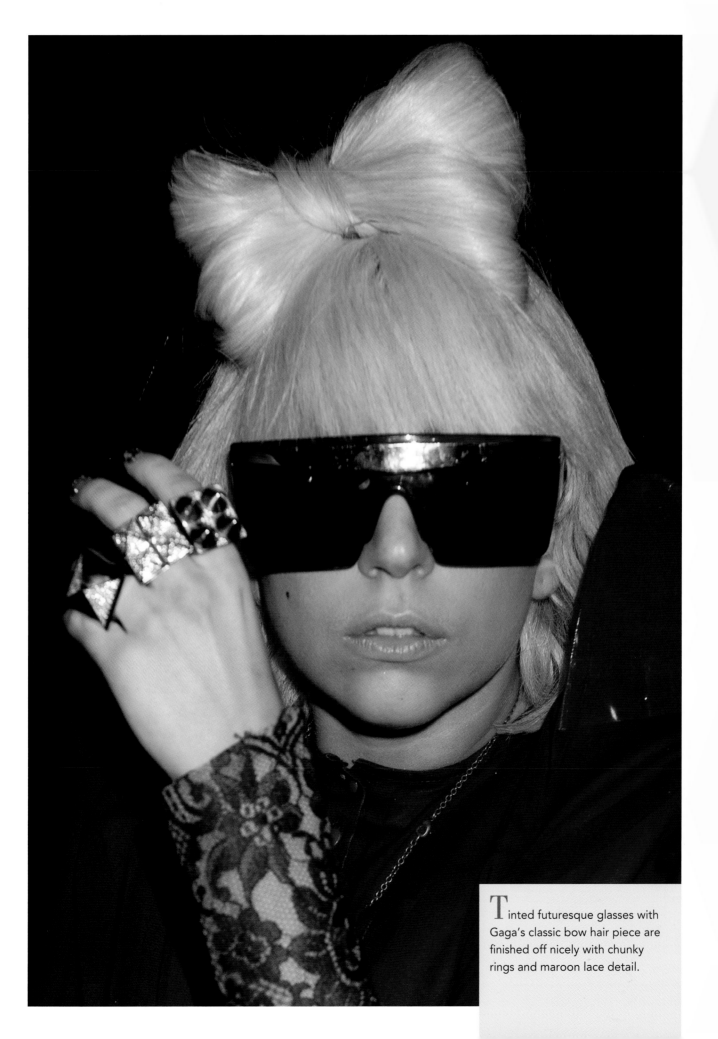

Tinted futuresque glasses with Gaga's classic bow hair piece are finished off nicely with chunky rings and maroon lace detail.

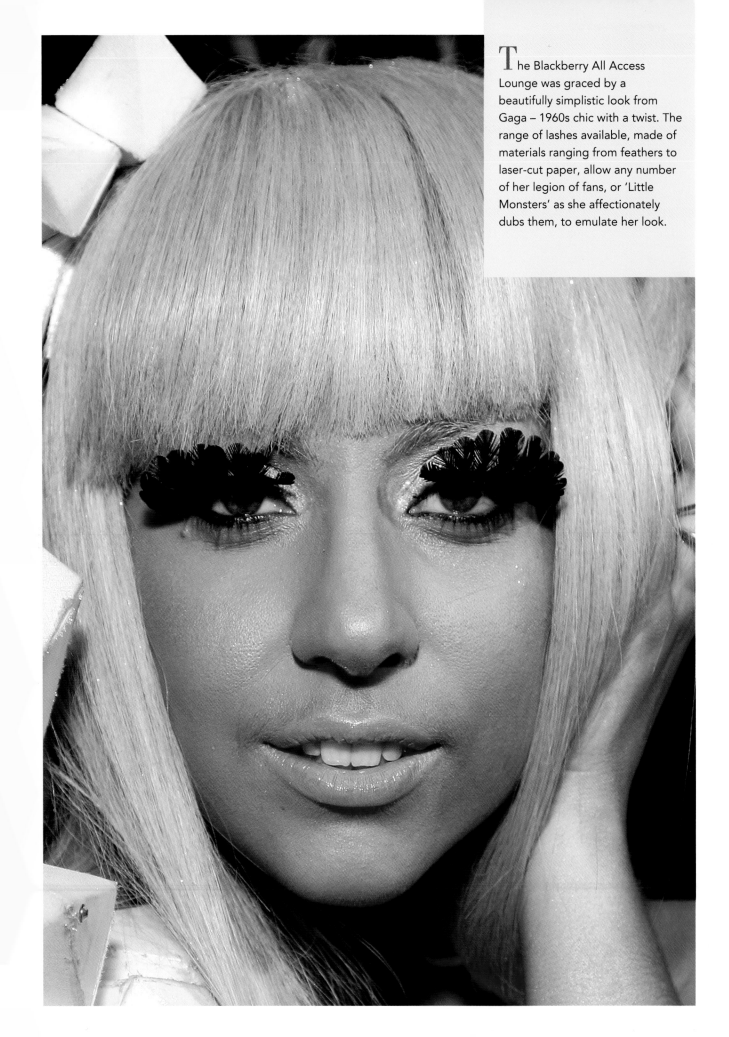

The Blackberry All Access Lounge was graced by a beautifully simplistic look from Gaga – 1960s chic with a twist. The range of lashes available, made of materials ranging from feathers to laser-cut paper, allow any number of her legion of fans, or 'Little Monsters' as she affectionately dubs them, to emulate her look.

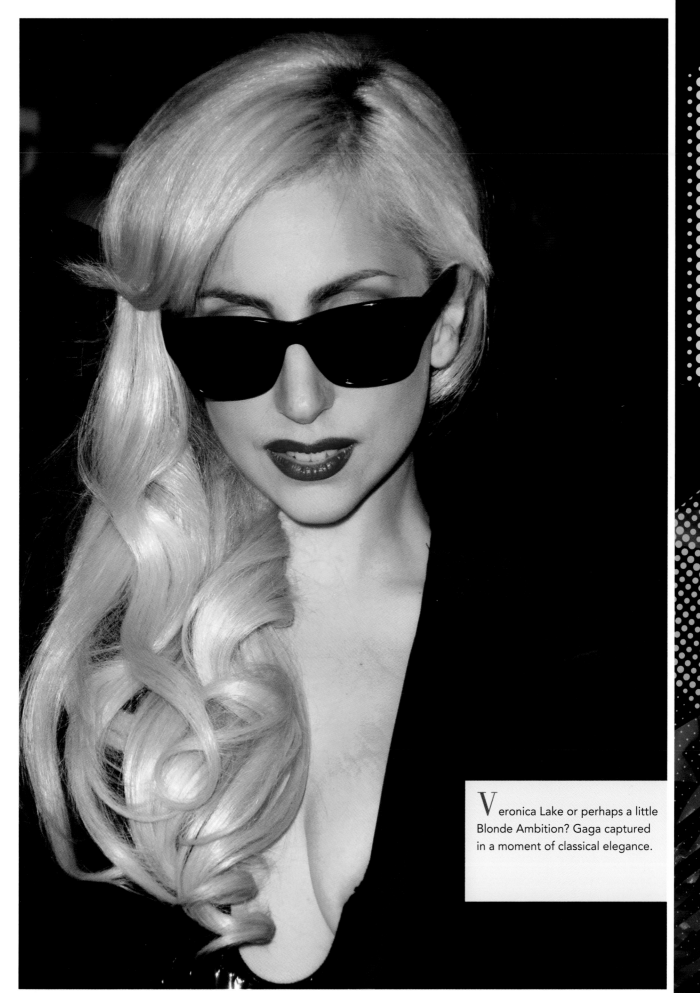

Veronica Lake or perhaps a little Blonde Ambition? Gaga captured in a moment of classical elegance.

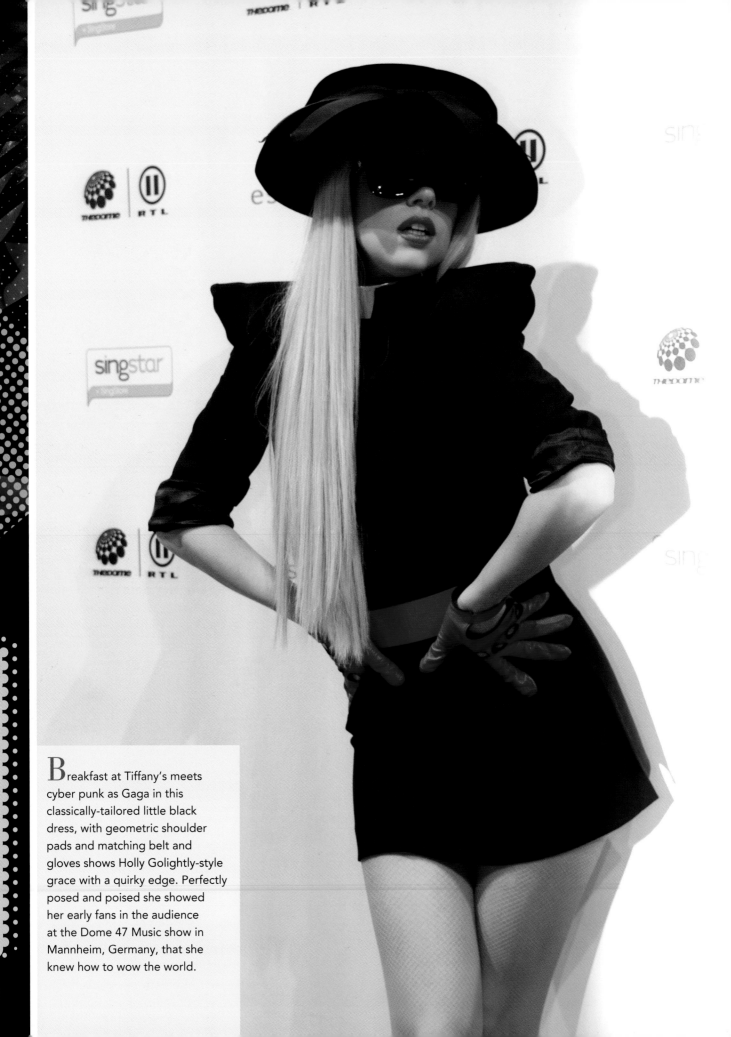

Breakfast at Tiffany's meets cyber punk as Gaga in this classically-tailored little black dress, with geometric shoulder pads and matching belt and gloves shows Holly Golightly-style grace with a quirky edge. Perfectly posed and poised she showed her early fans in the audience at the Dome 47 Music show in Mannheim, Germany, that she knew how to wow the world.

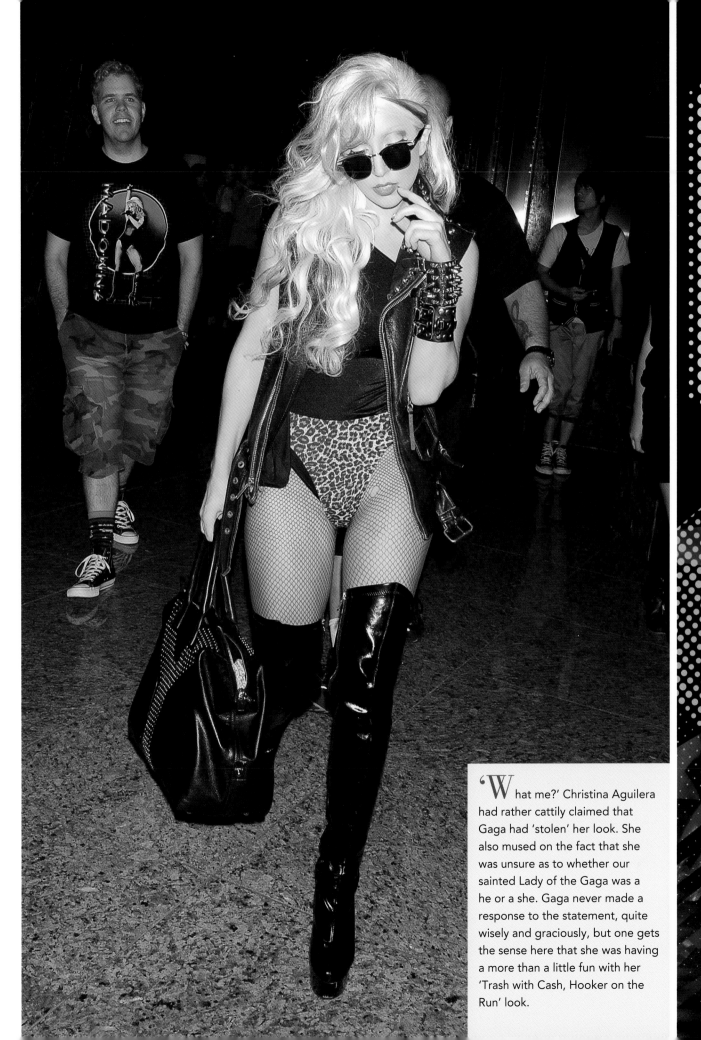

'What me?' Christina Aguilera had rather cattily claimed that Gaga had 'stolen' her look. She also mused on the fact that she was unsure as to whether our sainted Lady of the Gaga was a he or a she. Gaga never made a response to the statement, quite wisely and graciously, but one gets the sense here that she was having a more than a little fun with her 'Trash with Cash, Hooker on the Run' look.

GAGGING FOR GAGA

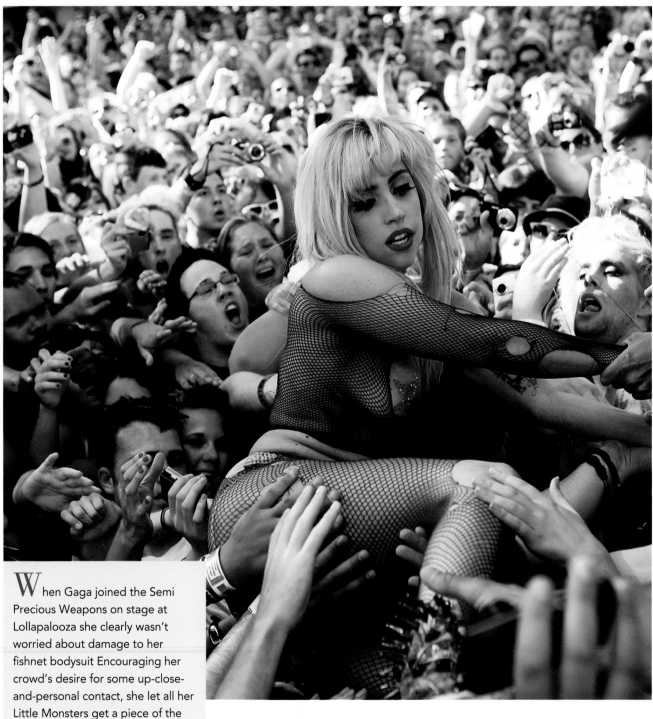

When Gaga joined the Semi Precious Weapons on stage at Lollapalooza she clearly wasn't worried about damage to her fishnet bodysuit Encouraging her crowd's desire for some up-close-and-personal contact, she let all her Little Monsters get a piece of the action.taking the phrase 'pressing the flesh' to a whole new level...

HIGHLIGHTS: HAIR & HATS

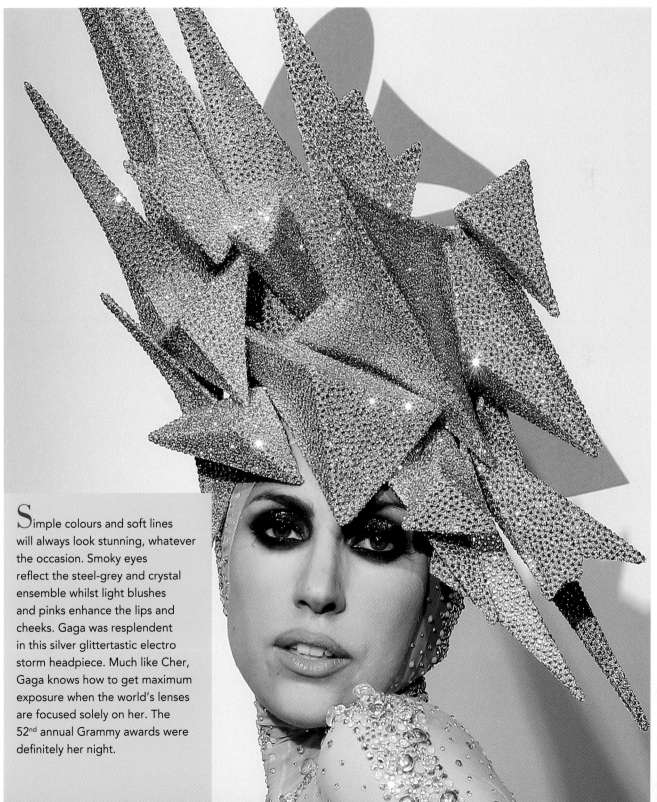

Simple colours and soft lines will always look stunning, whatever the occasion. Smoky eyes reflect the steel-grey and crystal ensemble whilst light blushes and pinks enhance the lips and cheeks. Gaga was resplendent in this silver glittertastic electro storm headpiece. Much like Cher, Gaga knows how to get maximum exposure when the world's lenses are focused solely on her. The 52nd annual Grammy awards were definitely her night.

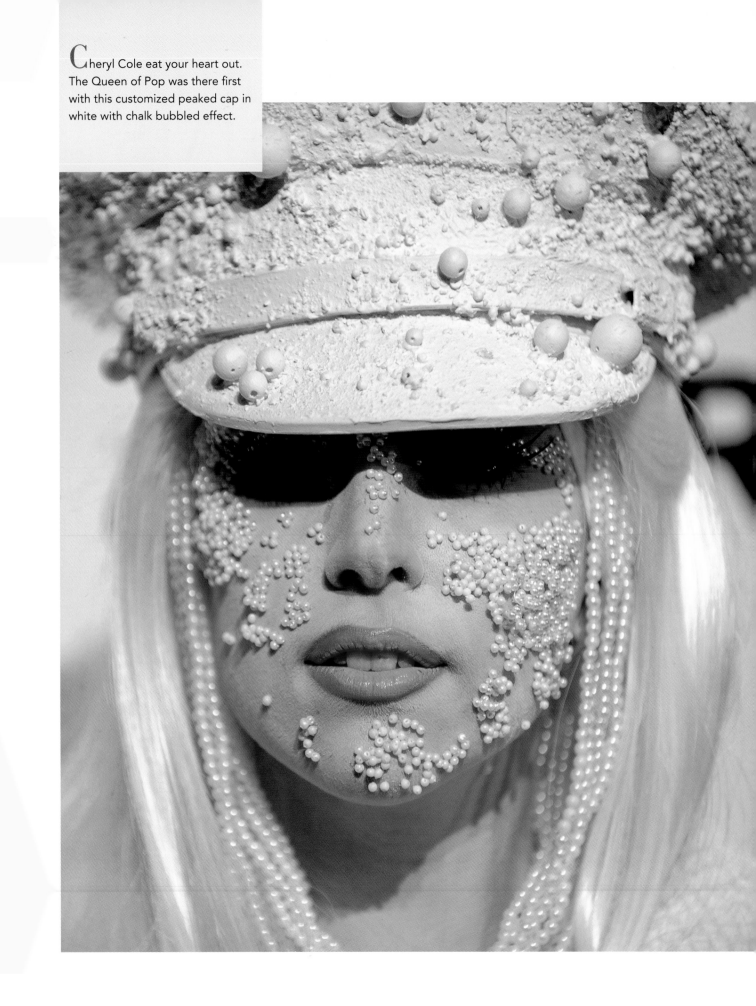

Cheryl Cole eat your heart out.
The Queen of Pop was there first
with this customized peaked cap in
white with chalk bubbled effect.

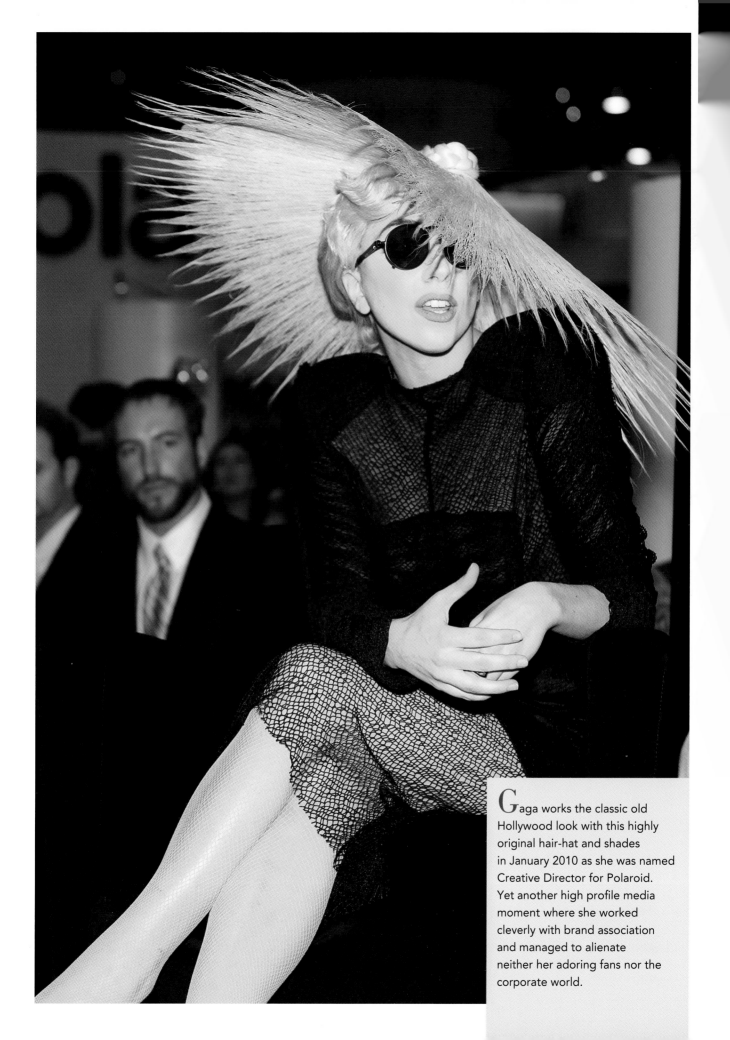

Gaga works the classic old Hollywood look with this highly original hair-hat and shades in January 2010 as she was named Creative Director for Polaroid. Yet another high profile media moment where she worked cleverly with brand association and managed to alienate neither her adoring fans nor the corporate world.

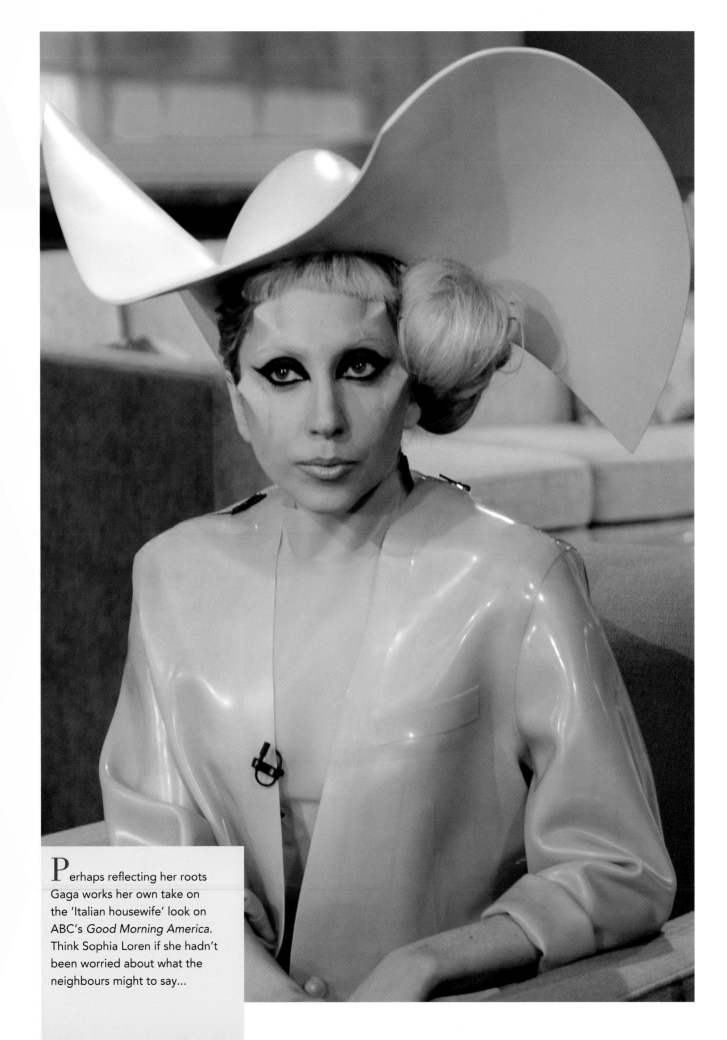

Perhaps reflecting her roots Gaga works her own take on the 'Italian housewife' look on ABC's *Good Morning America*. Think Sophia Loren if she hadn't been worried about what the neighbours might to say...

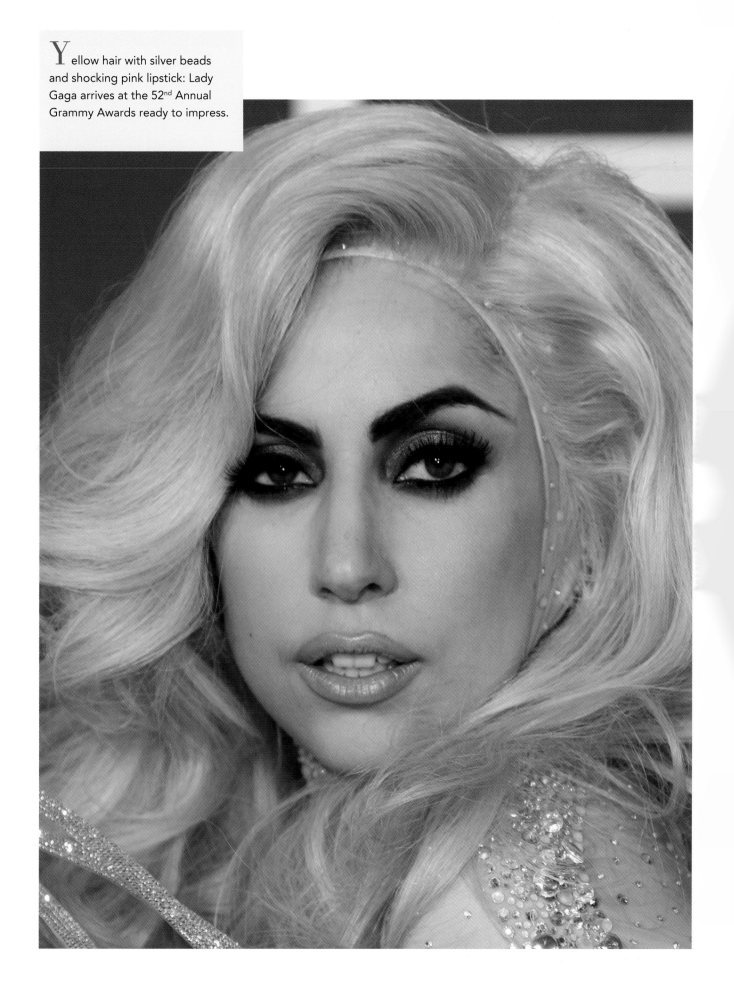

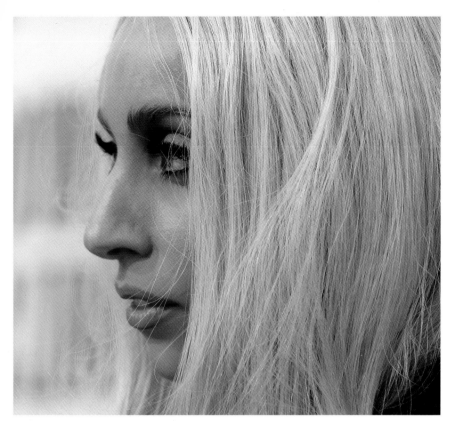

A slightly pensive Gaga at the 2010 MTV video music awards.

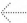

Maxing up the black and white eyeliner and heavy lashes. Early critics labelled Gaga as looking like 'a bad Jersey Shore reject'. Matched with a mass of fly-away curls, here the effect is more Goldie Hawn 'kooky' than raw-shore.

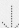

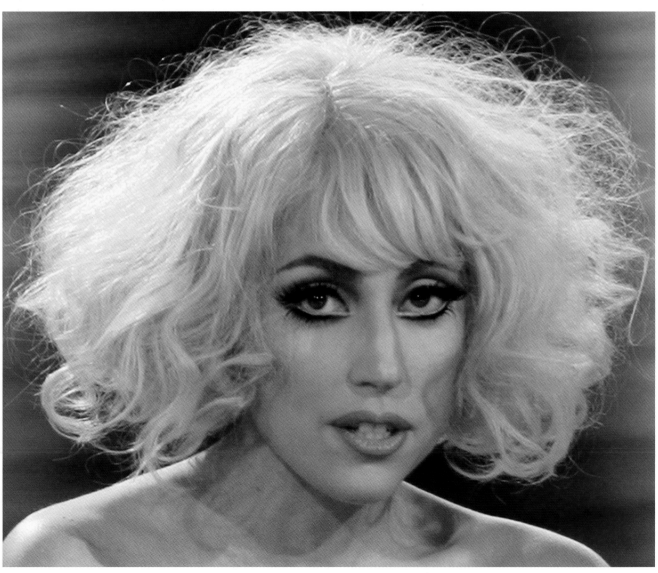

Gaga wowed the UK as she took centre stage in this elaborate white lace bodysuit and candy floss hair-piece that can only be described as Marie Antoinette punkette. Her performance at the 2010 Brits was truly memorable and proved once again how well she could combine the theatre of soaring multimedia visuals while delivering a stand-out vocal performance. A modern, makeshift pompadour captured her trademark outrageous profile. The lace pieces are glued to her face and woven through the piles of hair. The look is startling and yet bafflingly elegant.

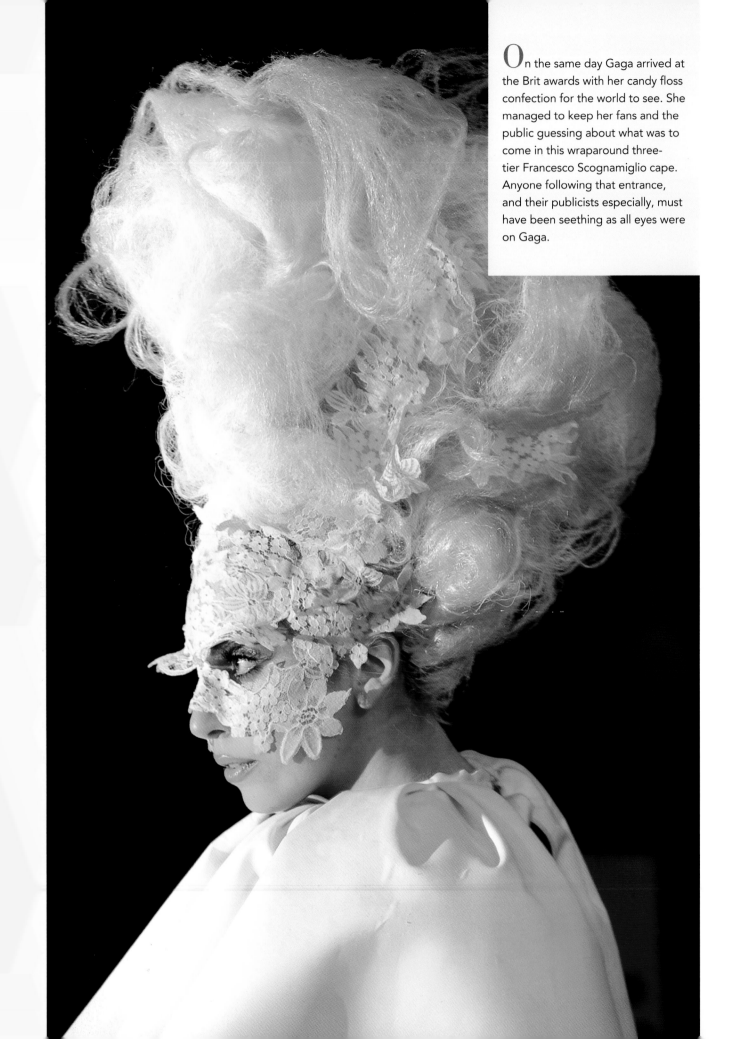

On the same day Gaga arrived at the Brit awards with her candy floss confection for the world to see. She managed to keep her fans and the public guessing about what was to come in this wraparound three-tier Francesco Scognamiglio cape. Anyone following that entrance, and their publicists especially, must have been seething as all eyes were on Gaga.

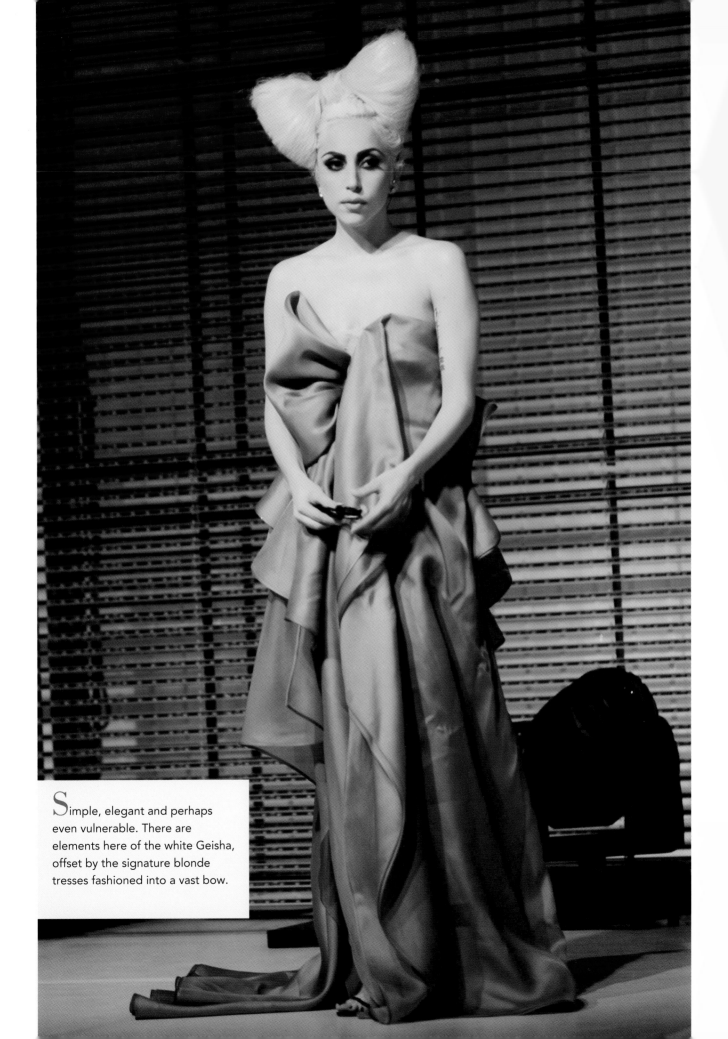

Simple, elegant and perhaps even vulnerable. There are elements here of the white Geisha, offset by the signature blonde tresses fashioned into a vast bow.

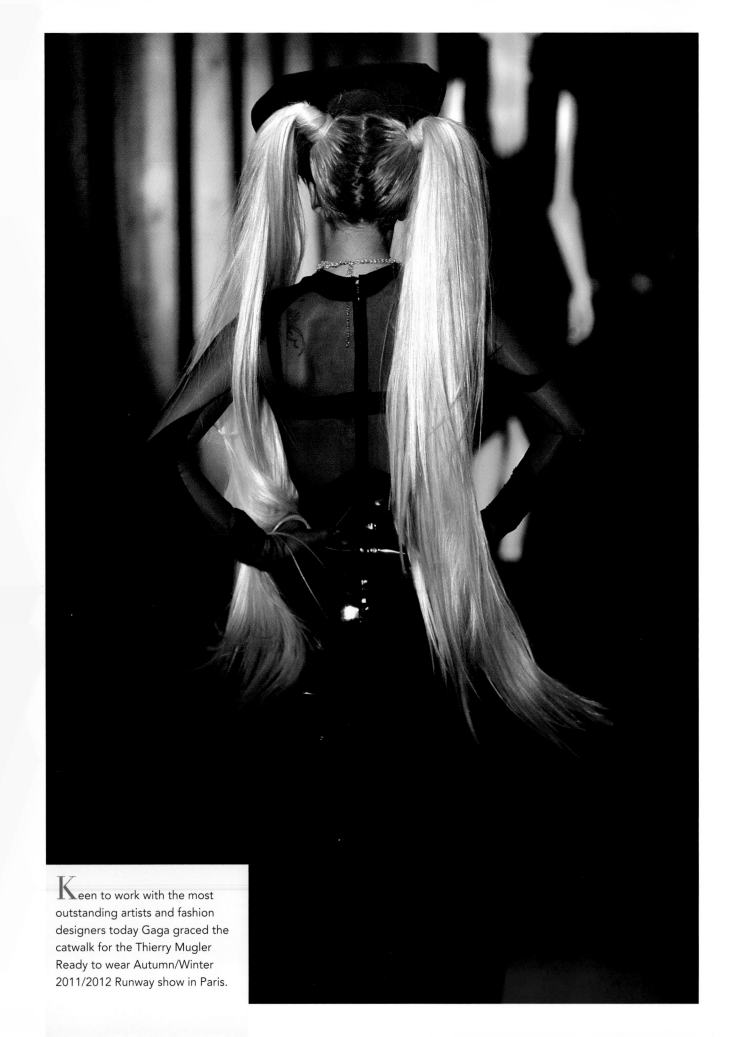

Keen to work with the most outstanding artists and fashion designers today Gaga graced the catwalk for the Thierry Mugler Ready to wear Autumn/Winter 2011/2012 Runway show in Paris.

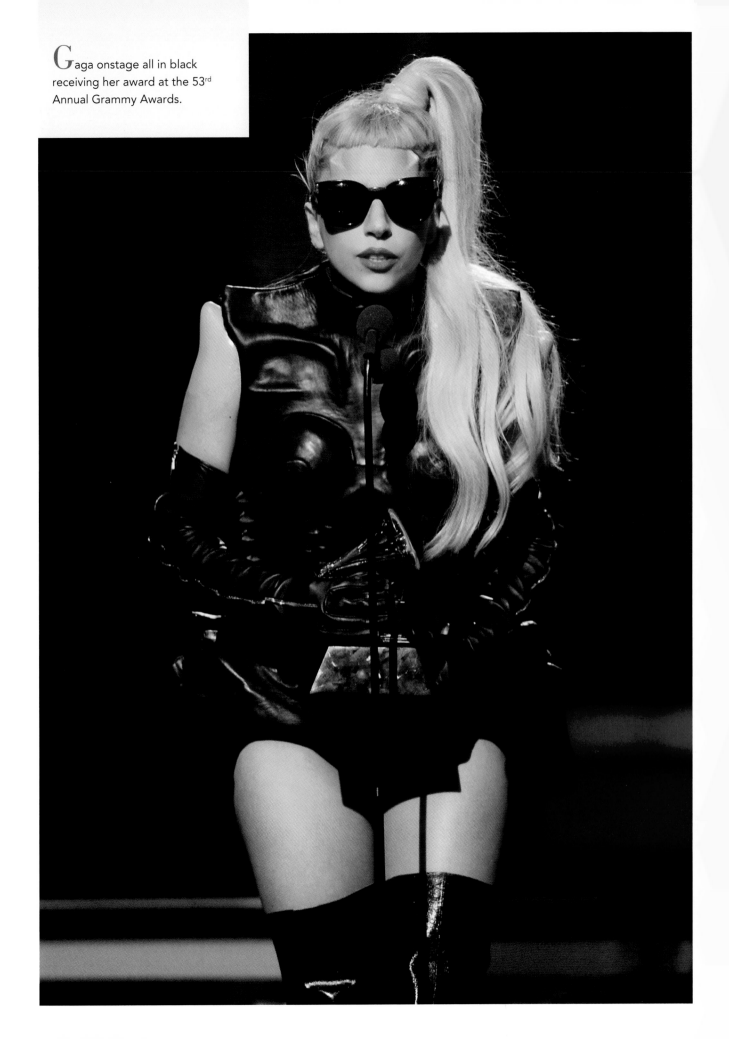

Gaga onstage all in black receiving her award at the 53rd Annual Grammy Awards.

INDEPENDENT SPIRIT

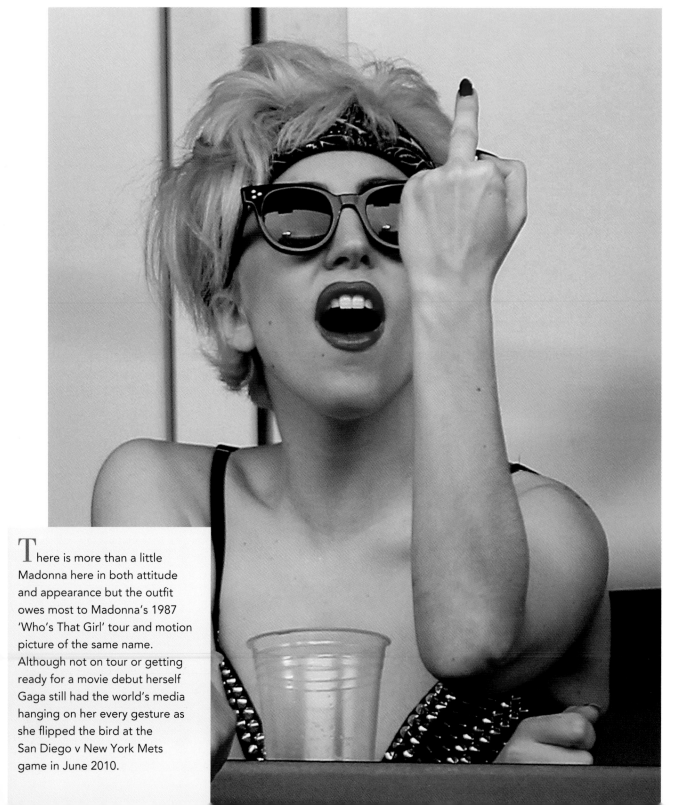

There is more than a little Madonna here in both attitude and appearance but the outfit owes most to Madonna's 1987 'Who's That Girl' tour and motion picture of the same name. Although not on tour or getting ready for a movie debut herself Gaga still had the world's media hanging on her every gesture as she flipped the bird at the San Diego v New York Mets game in June 2010.

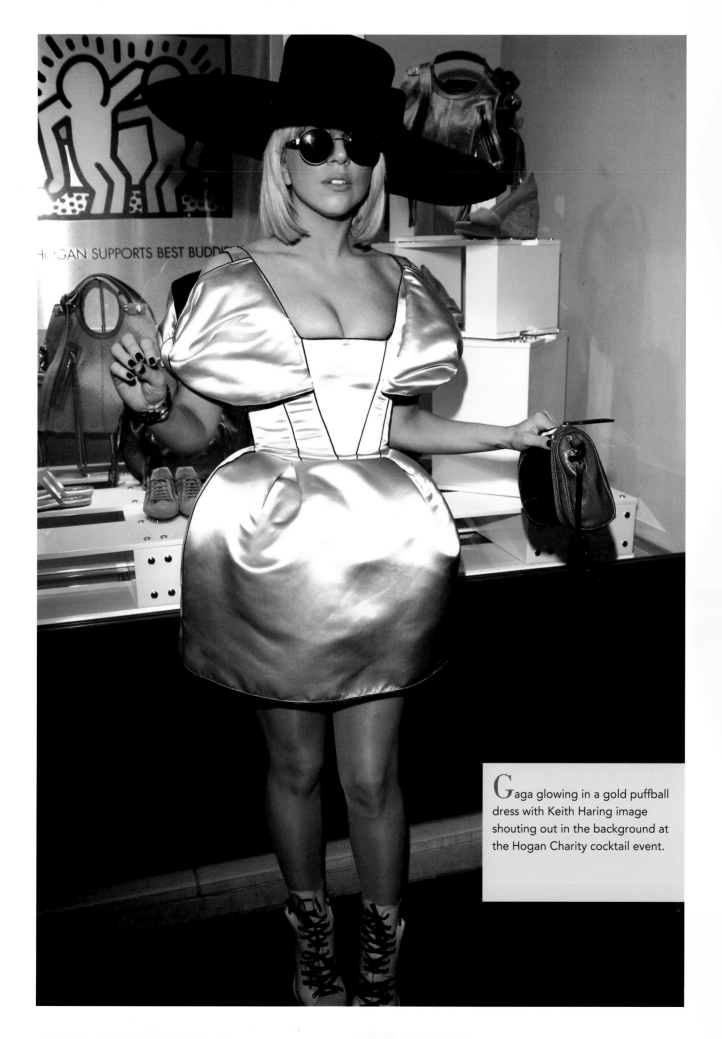

HOGAN SUPPORTS BEST BUDDIES

Gaga glowing in a gold puffball dress with Keith Haring image shouting out in the background at the Hogan Charity cocktail event.

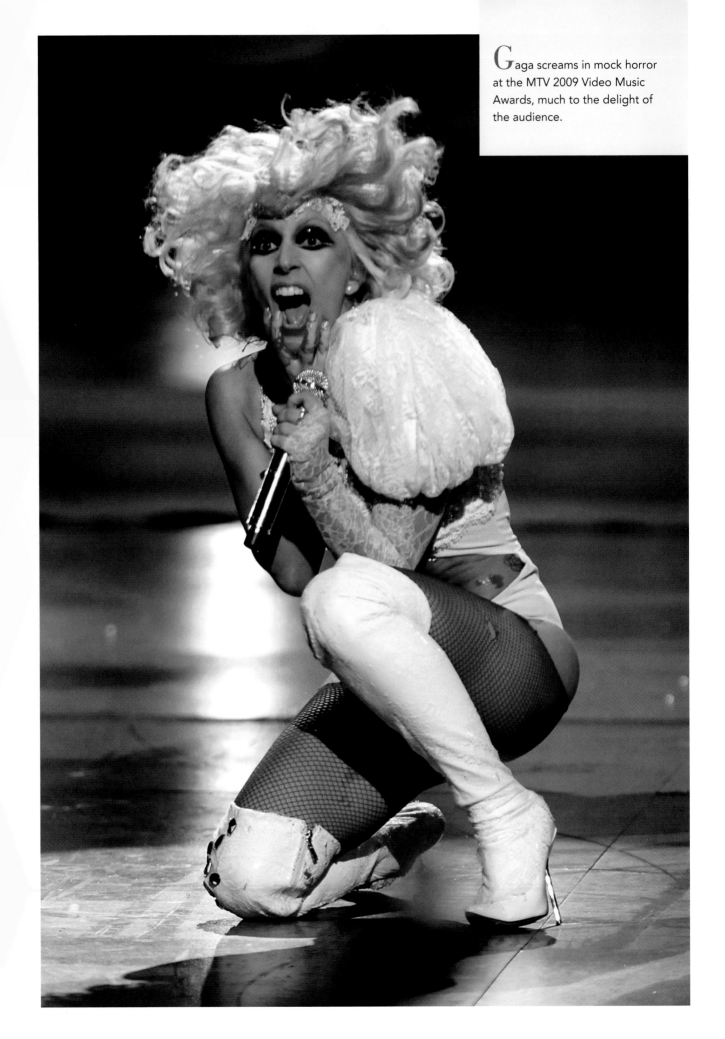

Gaga screams in mock horror at the MTV 2009 Video Music Awards, much to the delight of the audience.

JACKET FANTASTIC

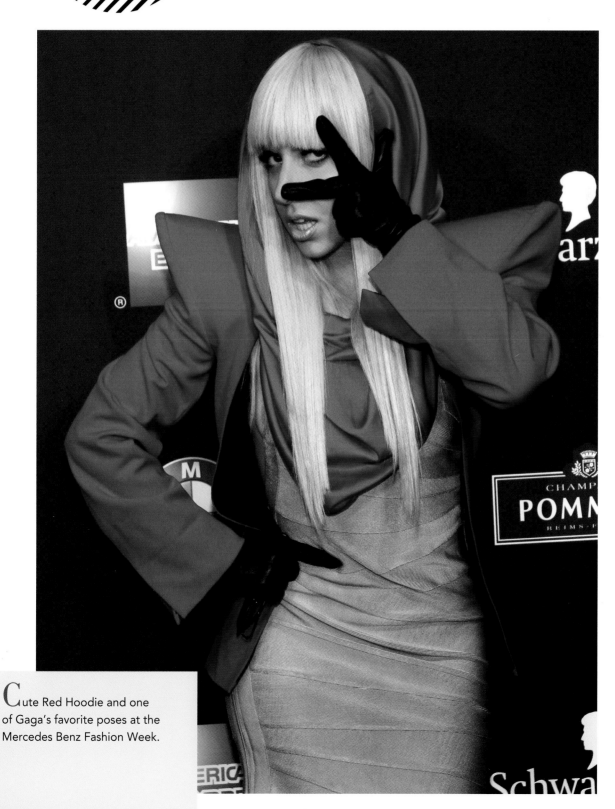

Cute Red Hoodie and one of Gaga's favorite poses at the Mercedes Benz Fashion Week.

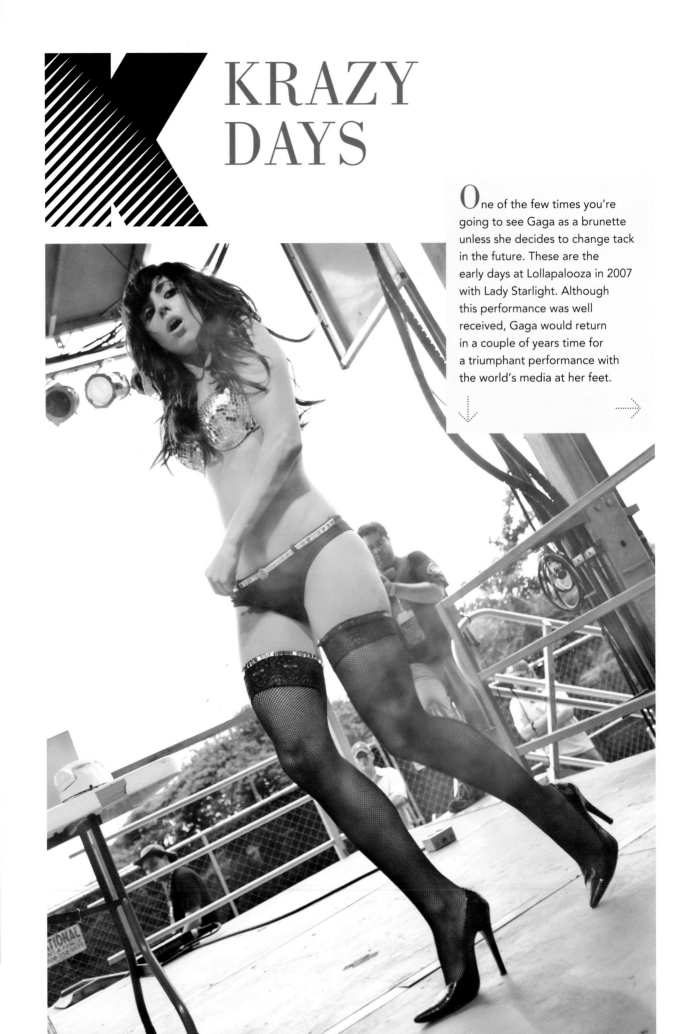

KRAZY DAYS

One of the few times you're going to see Gaga as a brunette unless she decides to change tack in the future. These are the early days at Lollapalooza in 2007 with Lady Starlight. Although this performance was well received, Gaga would return in a couple of years time for a triumphant performance with the world's media at her feet.

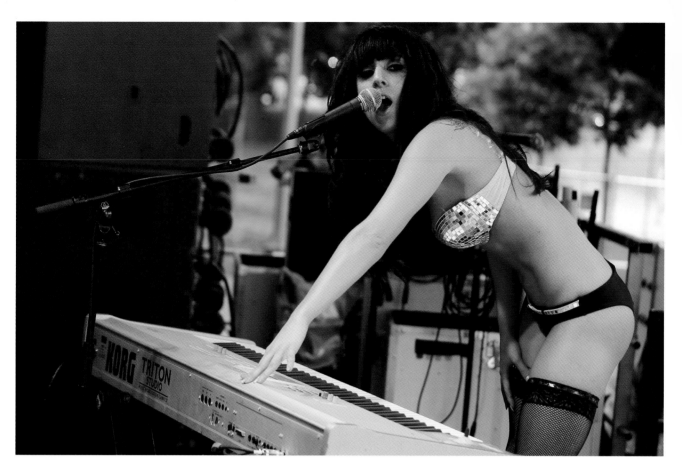

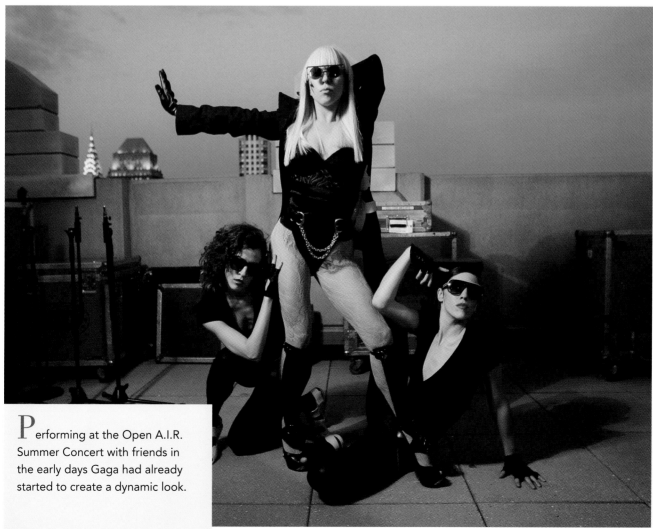

Performing at the Open A.I.R. Summer Concert with friends in the early days Gaga had already started to create a dynamic look.

LIVING THE DREAM

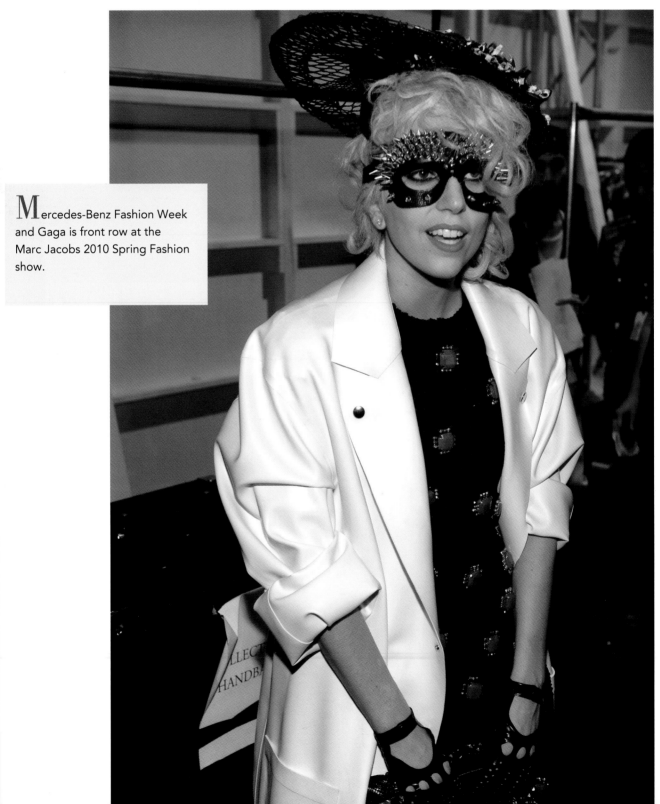

Mercedes-Benz Fashion Week and Gaga is front row at the Marc Jacobs 2010 Spring Fashion show.

MEAT AND GREET

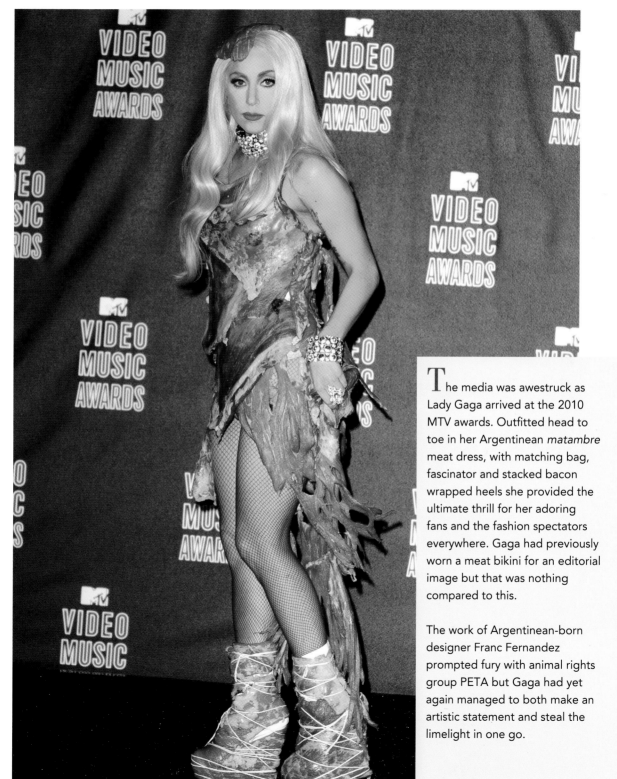

The media was awestruck as Lady Gaga arrived at the 2010 MTV awards. Outfitted head to toe in her Argentinean *matambre* meat dress, with matching bag, fascinator and stacked bacon wrapped heels she provided the ultimate thrill for her adoring fans and the fashion spectators everywhere. Gaga had previously worn a meat bikini for an editorial image but that was nothing compared to this.

The work of Argentinean-born designer Franc Fernandez prompted fury with animal rights group PETA but Gaga had yet again managed to both make an artistic statement and steal the limelight in one go.

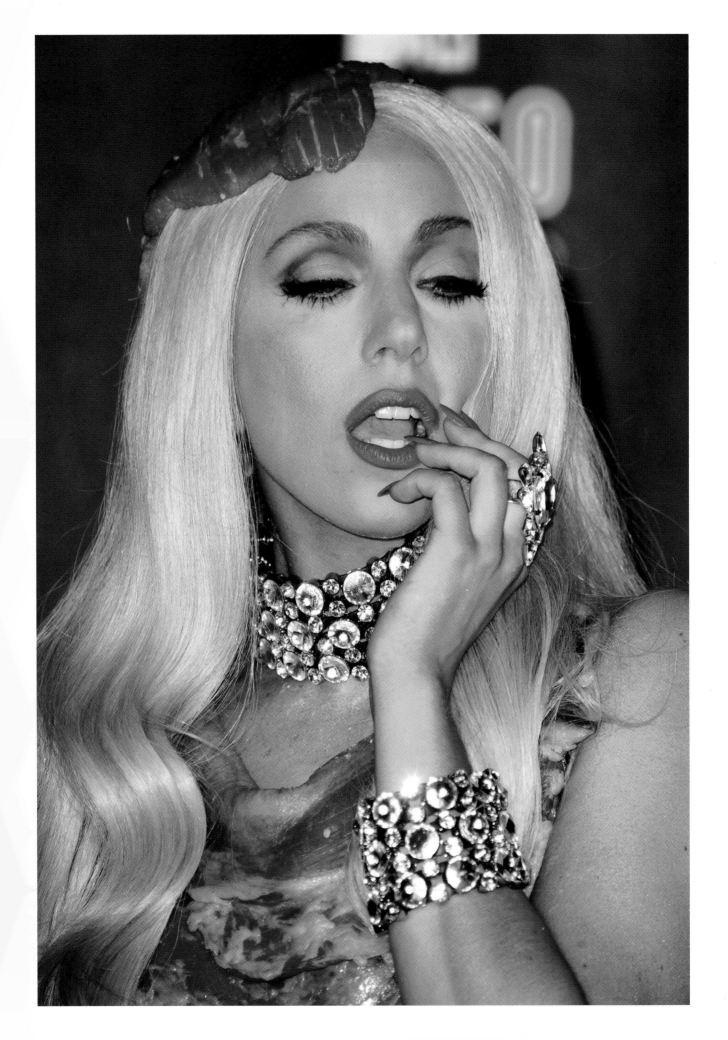

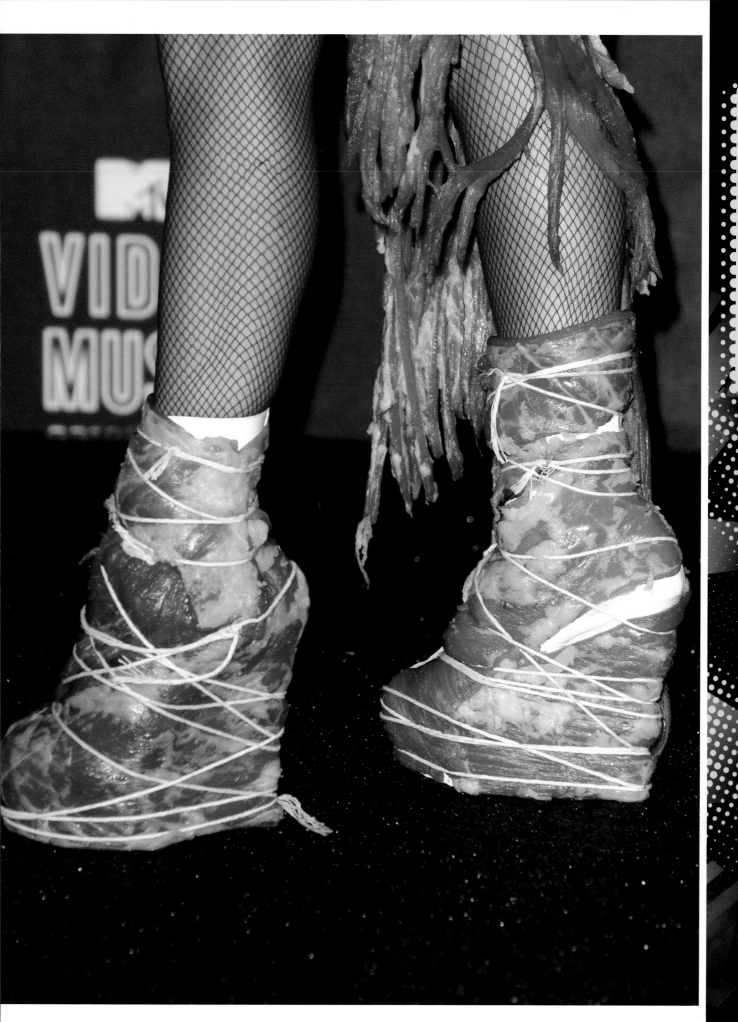

N NO RULES

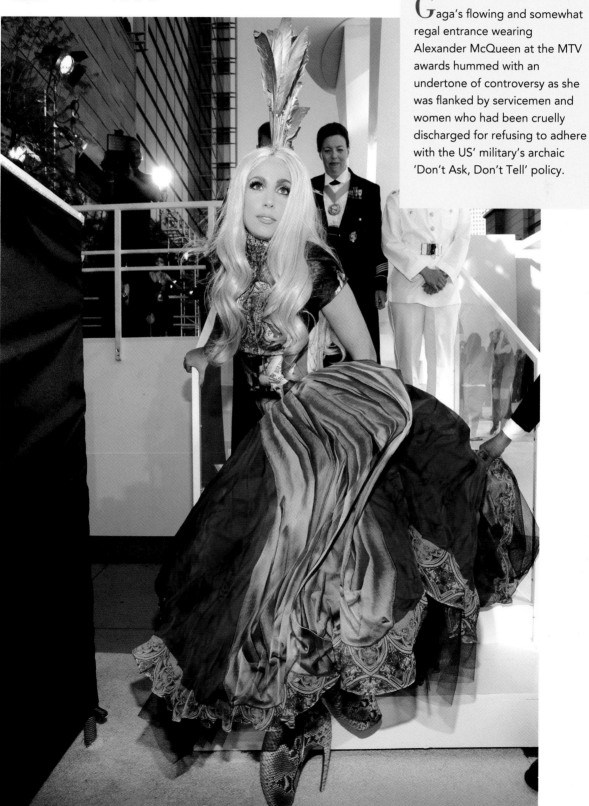

Gaga's flowing and somewhat regal entrance wearing Alexander McQueen at the MTV awards hummed with an undertone of controversy as she was flanked by servicemen and women who had been cruelly discharged for refusing to adhere with the US' military's archaic 'Don't Ask, Don't Tell' policy.

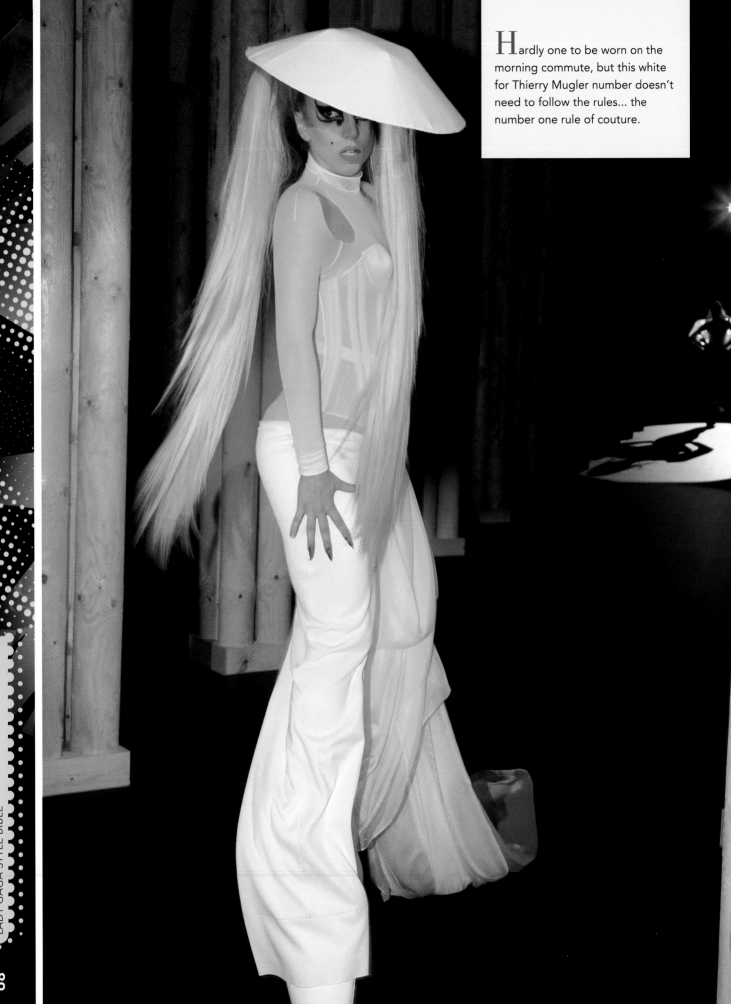

Hardly one to be worn on the morning commute, but this white for Thierry Mugler number doesn't need to follow the rules... the number one rule of couture.

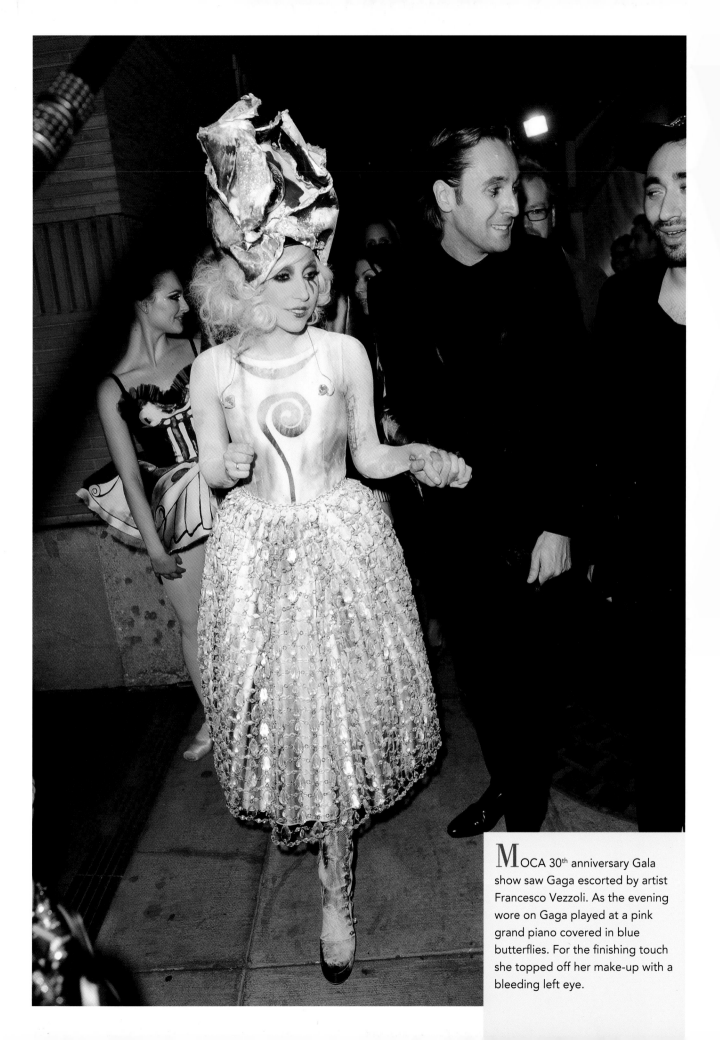

MOCA 30th anniversary Gala show saw Gaga escorted by artist Francesco Vezzoli. As the evening wore on Gaga played at a pink grand piano covered in blue butterflies. For the finishing touch she topped off her make-up with a bleeding left eye.

OPTICAL ILLUSION

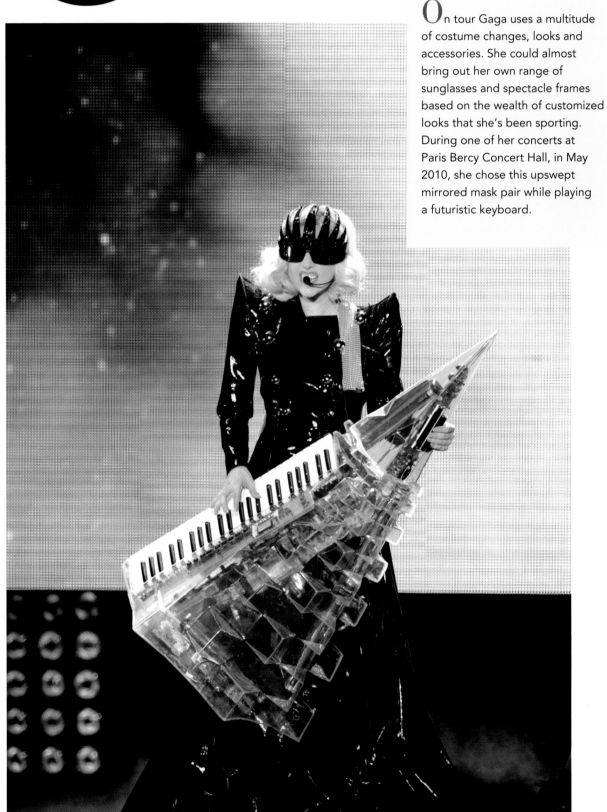

On tour Gaga uses a multitude of costume changes, looks and accessories. She could almost bring out her own range of sunglasses and spectacle frames based on the wealth of customized looks that she's been sporting. During one of her concerts at Paris Bercy Concert Hall, in May 2010, she chose this upswept mirrored mask pair while playing a futuristic keyboard.

Cute and simple in this white strappy dress with bug-eyed diamond eyewear on NBC's *Today* show.

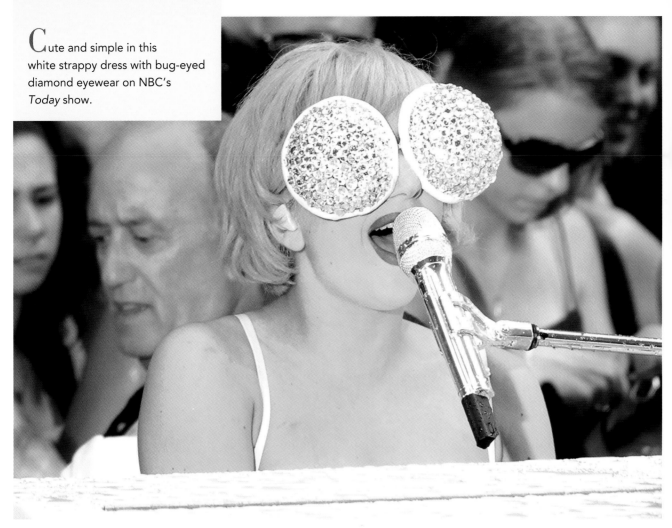

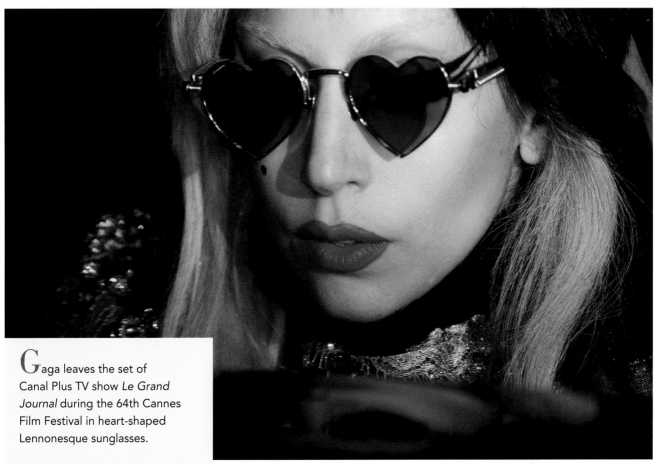

Gaga leaves the set of Canal Plus TV show *Le Grand Journal* during the 64th Cannes Film Festival in heart-shaped Lennonesque sunglasses.

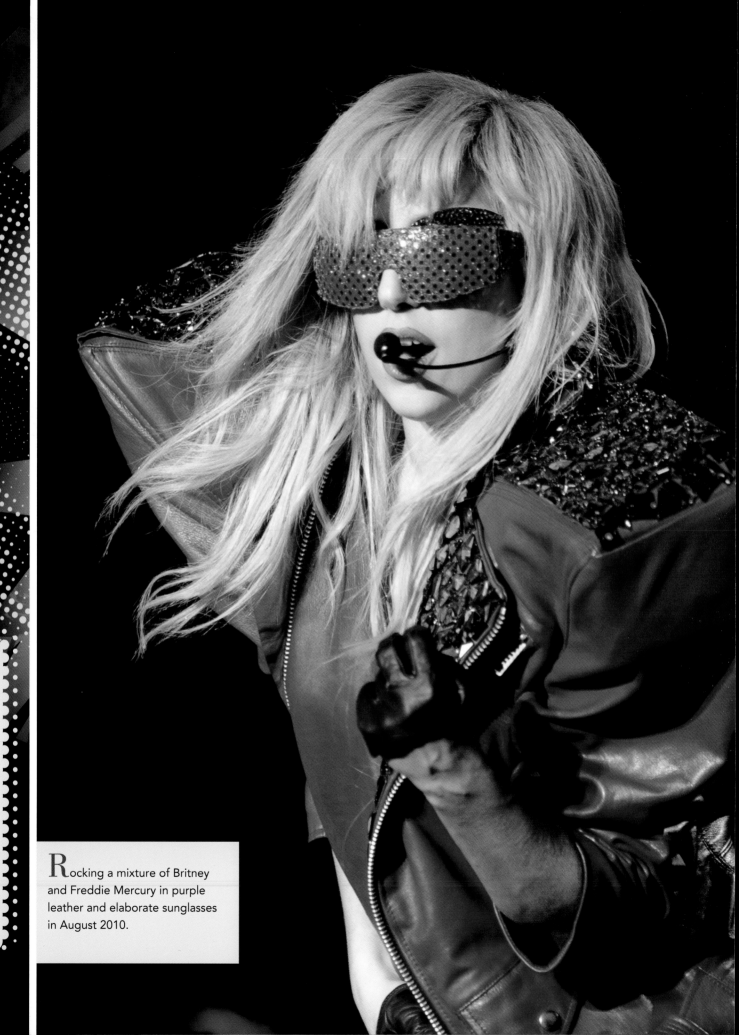

Rocking a mixture of Britney and Freddie Mercury in purple leather and elaborate sunglasses in August 2010.

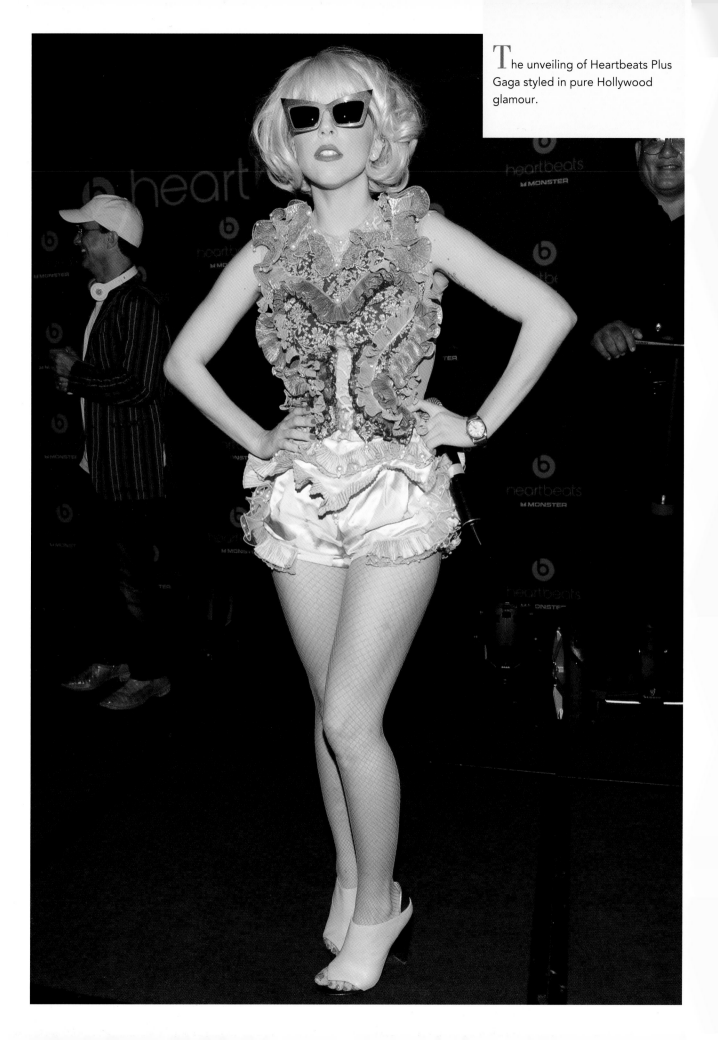

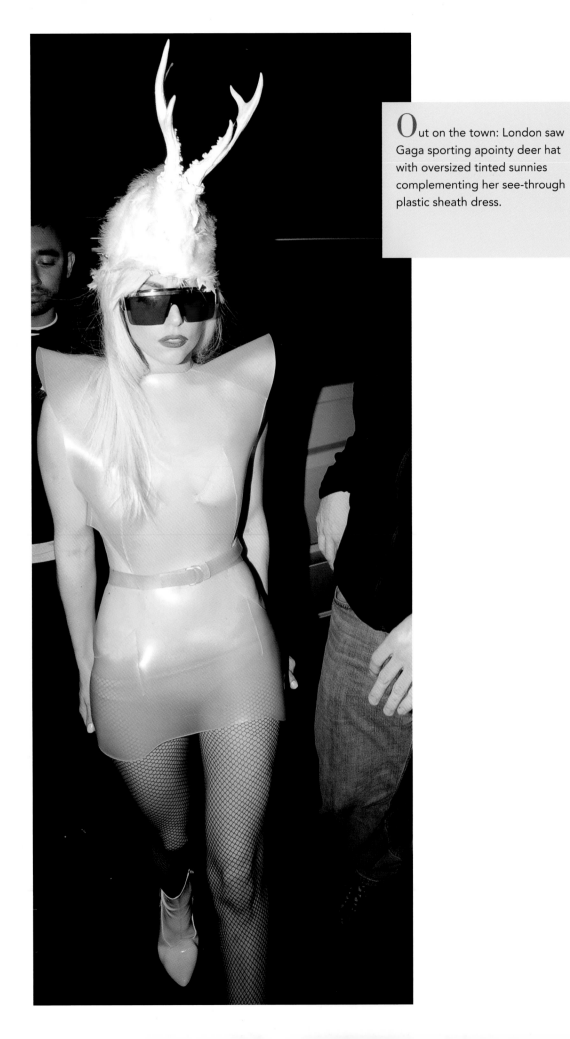

Out on the town: London saw Gaga sporting apointy deer hat with oversized tinted sunnies complementing her see-through plastic sheath dress.

PERFORMANCE PROVOCATEUR

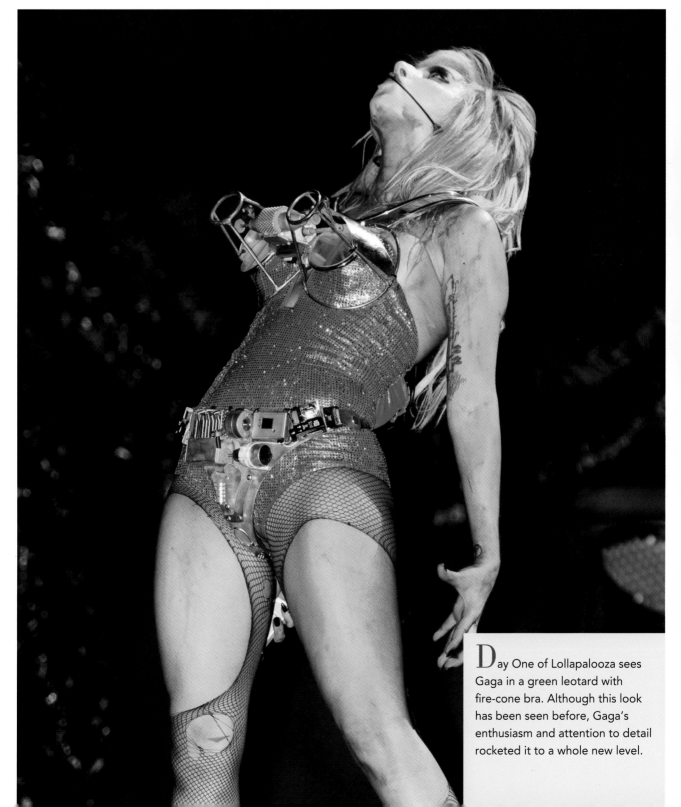

Day One of Lollapalooza sees Gaga in a green leotard with fire-cone bra. Although this look has been seen before, Gaga's enthusiasm and attention to detail rocketed it to a whole new level.

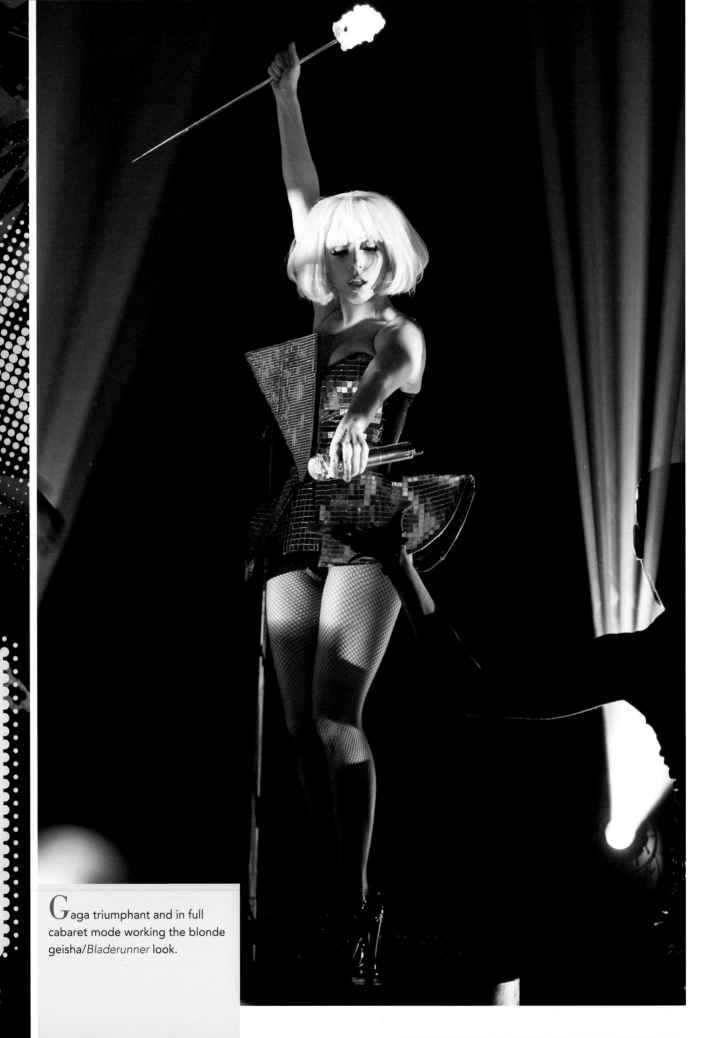

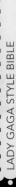

Gaga triumphant and in full cabaret mode working the blonde geisha/*Bladerunner* look.

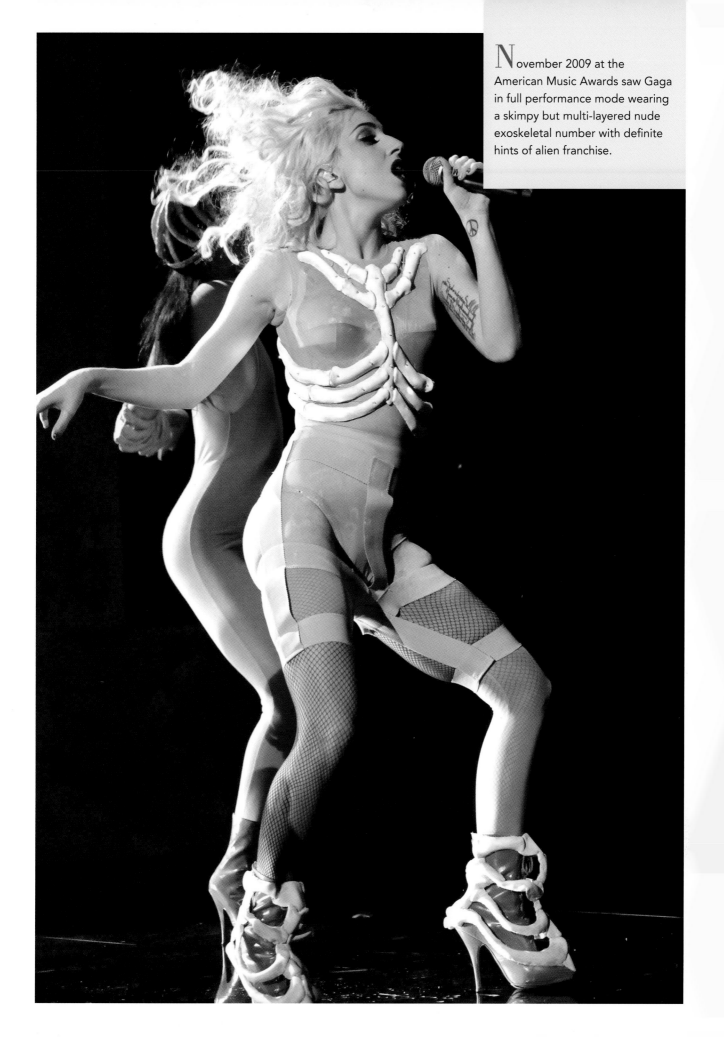

November 2009 at the American Music Awards saw Gaga in full performance mode wearing a skimpy but multi-layered nude exoskeletal number with definite hints of alien franchise.

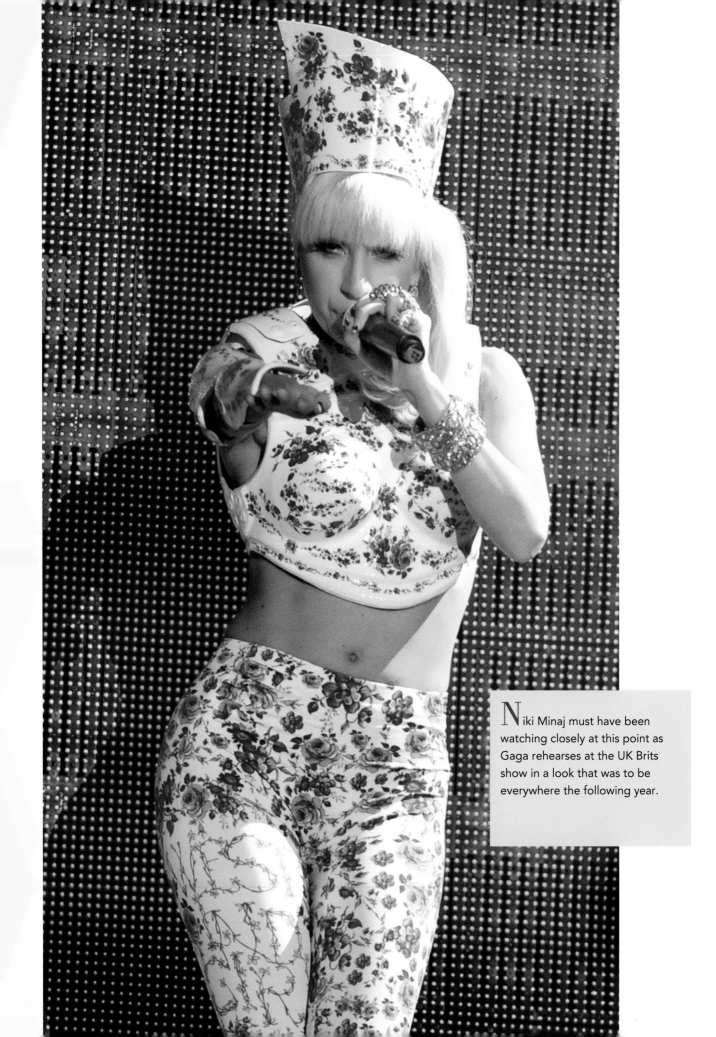

Niki Minaj must have been watching closely at this point as Gaga rehearses at the UK Brits show in a look that was to be everywhere the following year.

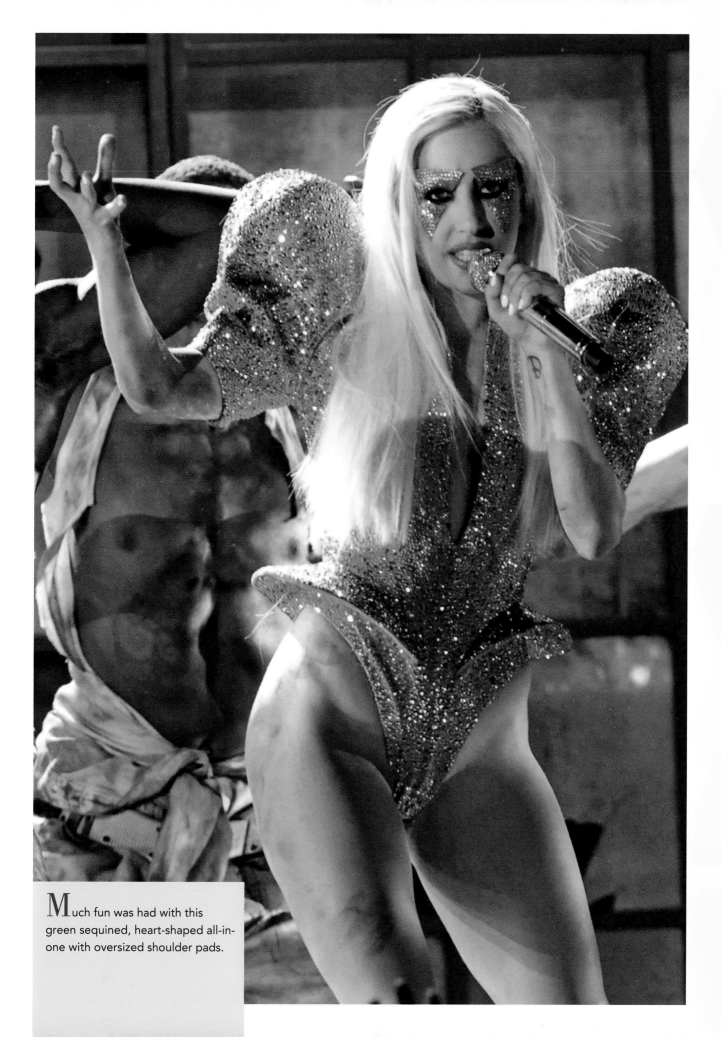

Much fun was had with this green sequined, heart-shaped all-in-one with oversized shoulder pads.

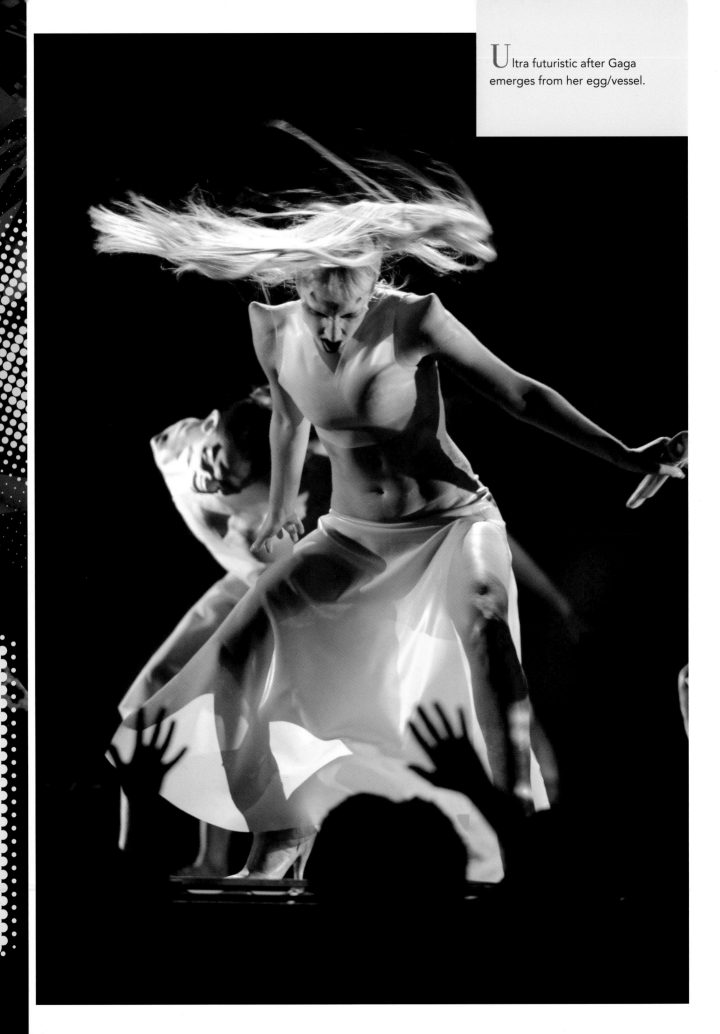

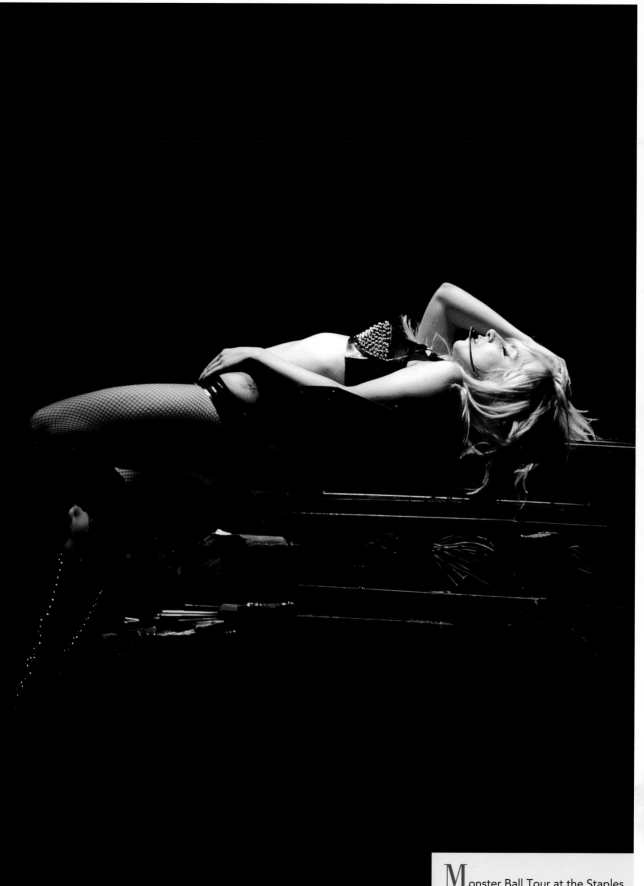

Monster Ball Tour at the Staples Centre August 2010 shows Gaga in repose.

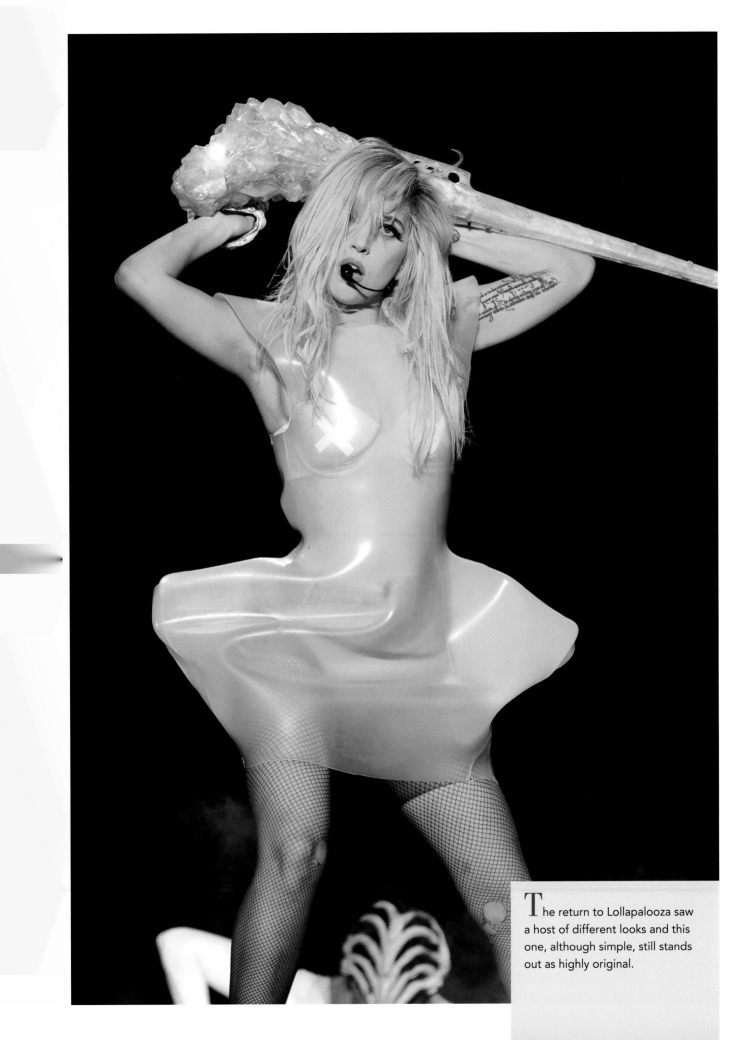

The return to Lollapalooza saw a host of different looks and this one, although simple, still stands out as highly original.

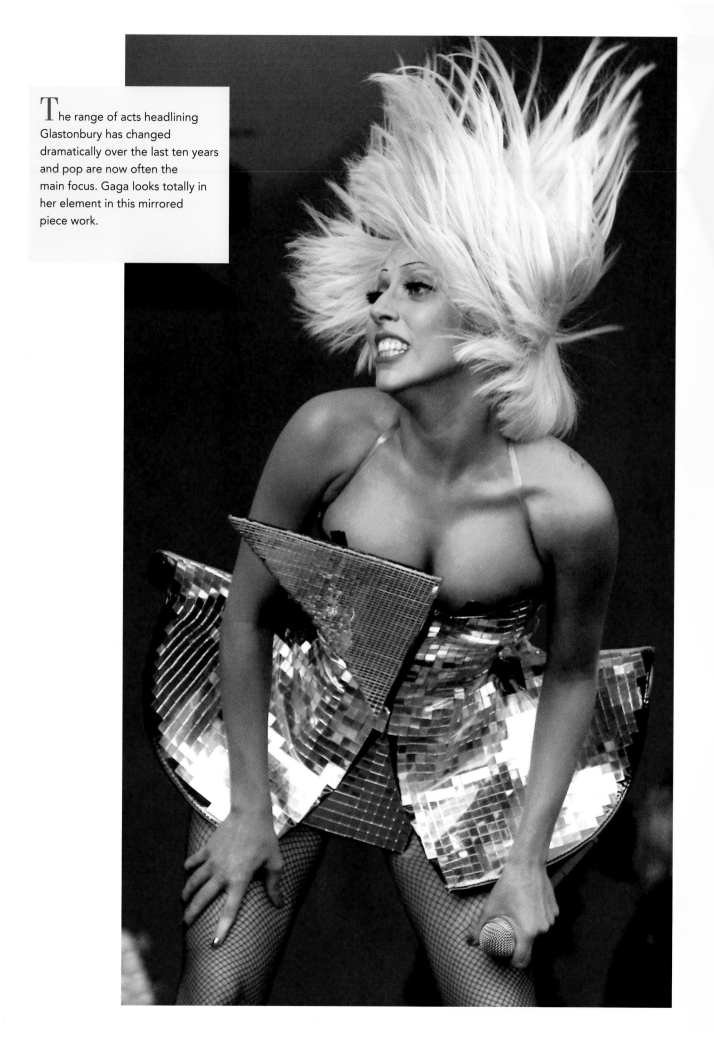

The range of acts headlining Glastonbury has changed dramatically over the last ten years and pop are now often the main focus. Gaga looks totally in her element in this mirrored piece work.

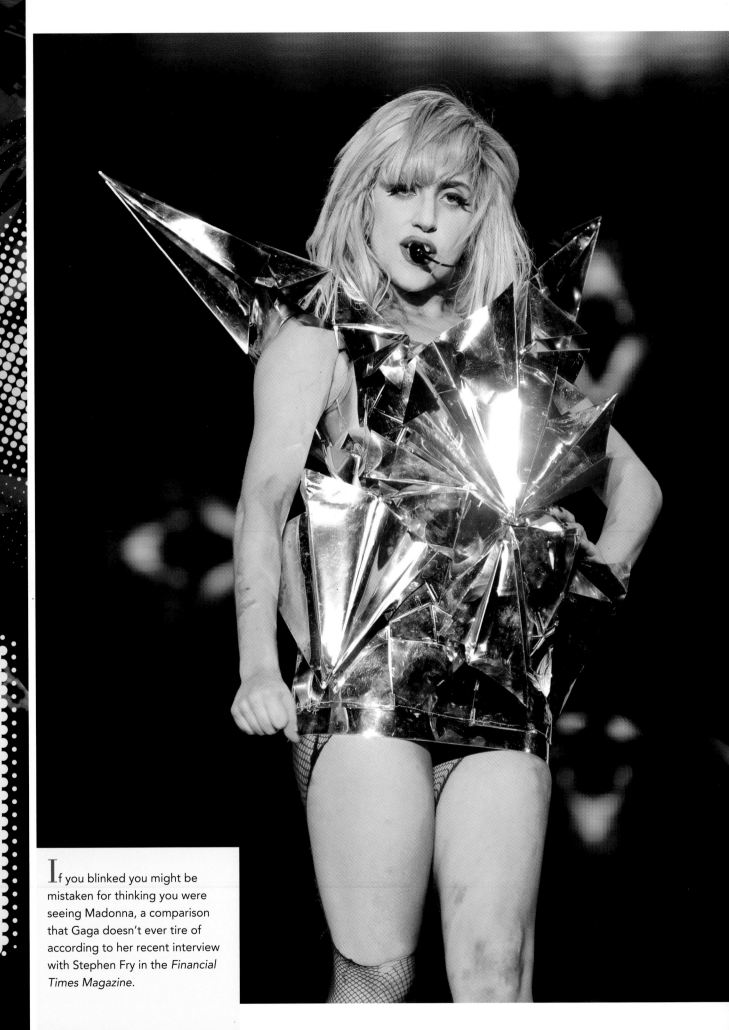

If you blinked you might be mistaken for thinking you were seeing Madonna, a comparison that Gaga doesn't ever tire of according to her recent interview with Stephen Fry in the *Financial Times Magazine*.

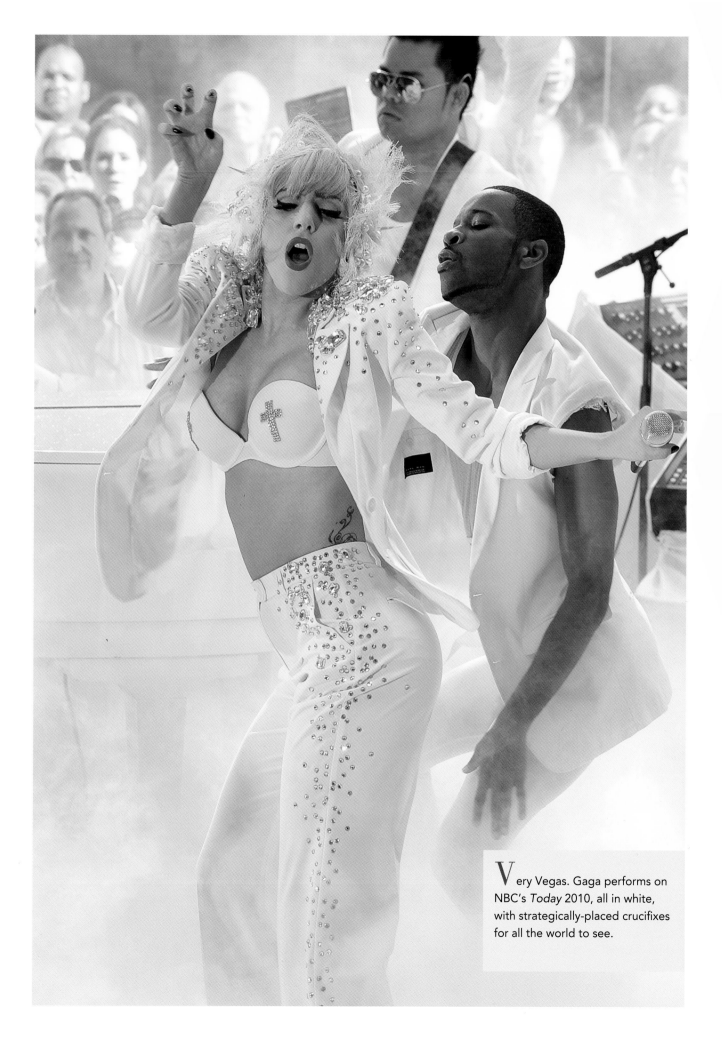

V ery Vegas. Gaga performs on NBC's *Today* 2010, all in white, with strategically-placed crucifixes for all the world to see.

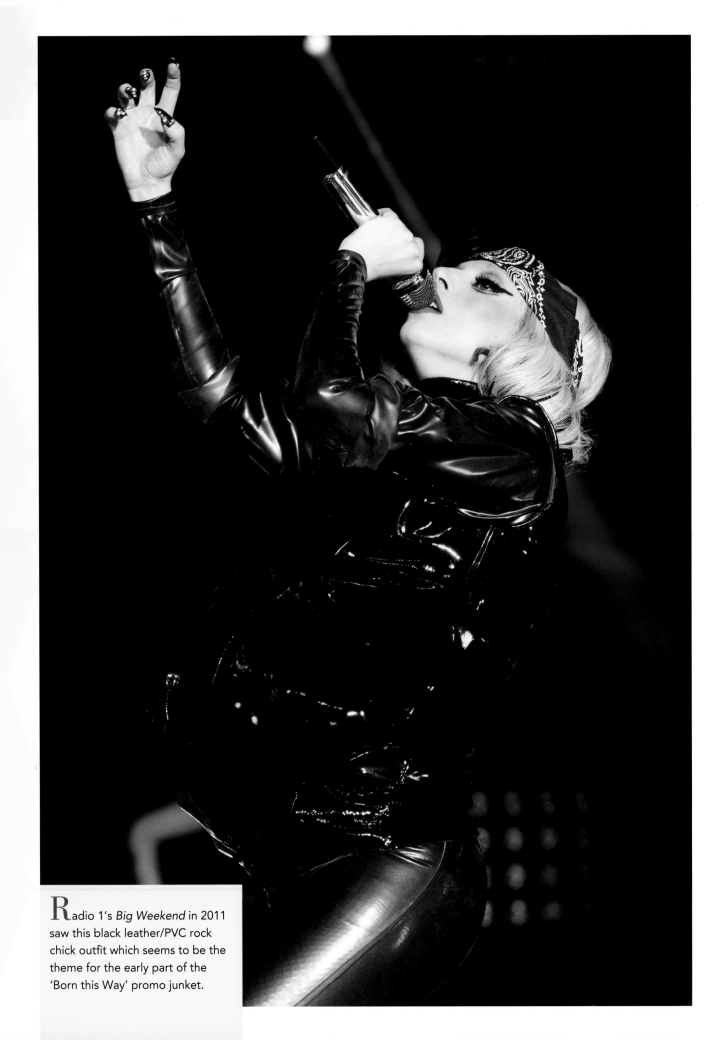

Radio 1's *Big Weekend* in 2011 saw this black leather/PVC rock chick outfit which seems to be the theme for the early part of the 'Born this Way' promo junket.

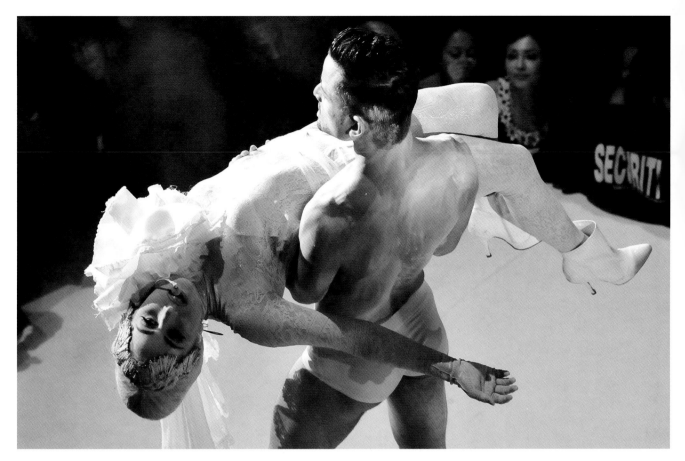

G aga looks as though she's loving it, promoting MAC's 'Viva Glam' in Tokyo April 2010.

A t the same charity concert in Japan for those suffering from HIV, Gaga was raised up for all to see dressed in virginal white.

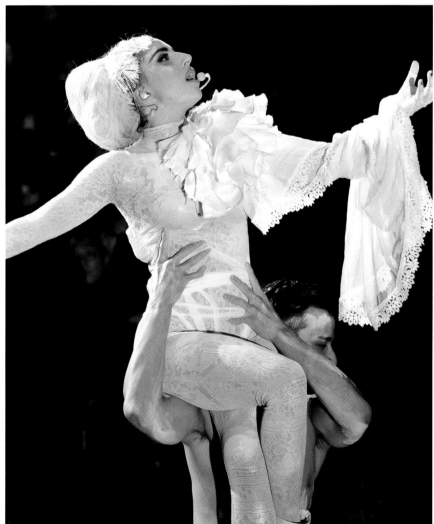

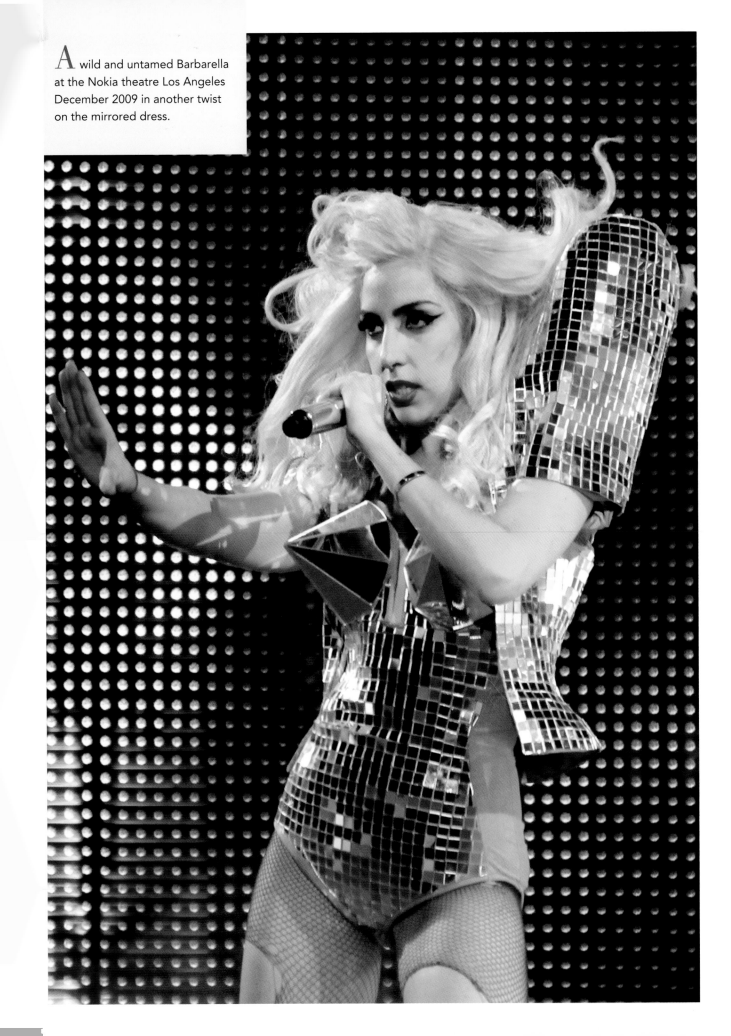

A wild and untamed Barbarella at the Nokia theatre Los Angeles December 2009 in another twist on the mirrored dress.

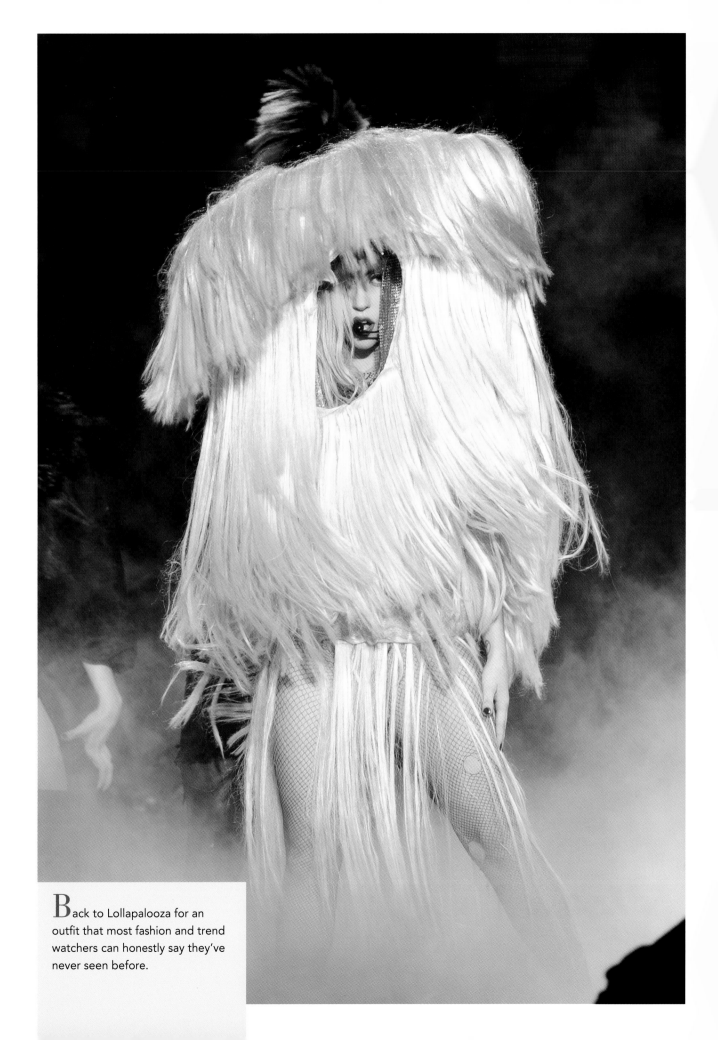

Back to Lollapalooza for an outfit that most fashion and trend watchers can honestly say they've never seen before.

QUEENS RULES

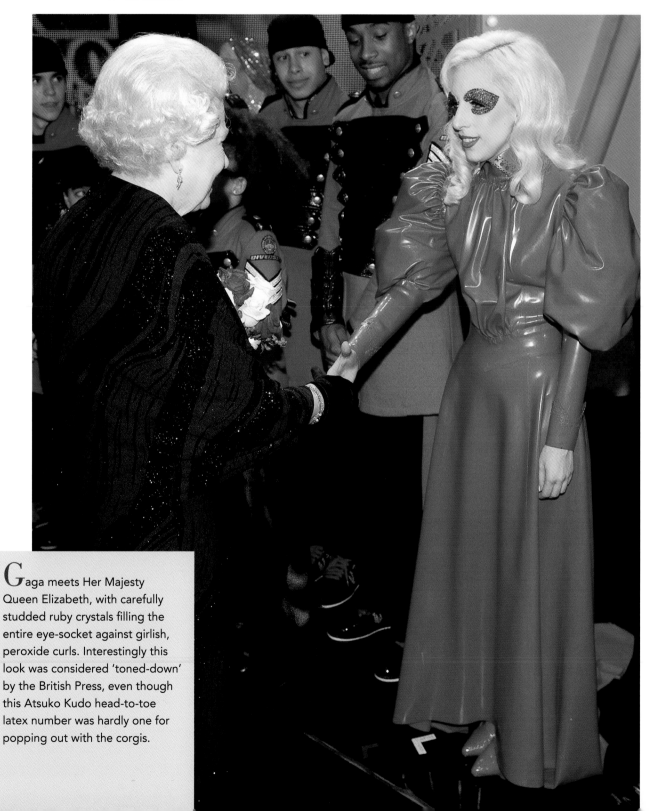

Gaga meets Her Majesty Queen Elizabeth, with carefully studded ruby crystals filling the entire eye-socket against girlish, peroxide curls. Interestingly this look was considered 'toned-down' by the British Press, even though this Atsuko Kudo head-to-toe latex number was hardly one for popping out with the corgis.

RETRO NODS

This performance on NBC's *Today* show at the Rockefeller Centre owes a lot to Madonna's 1987 tour look.

SEX
SELLS

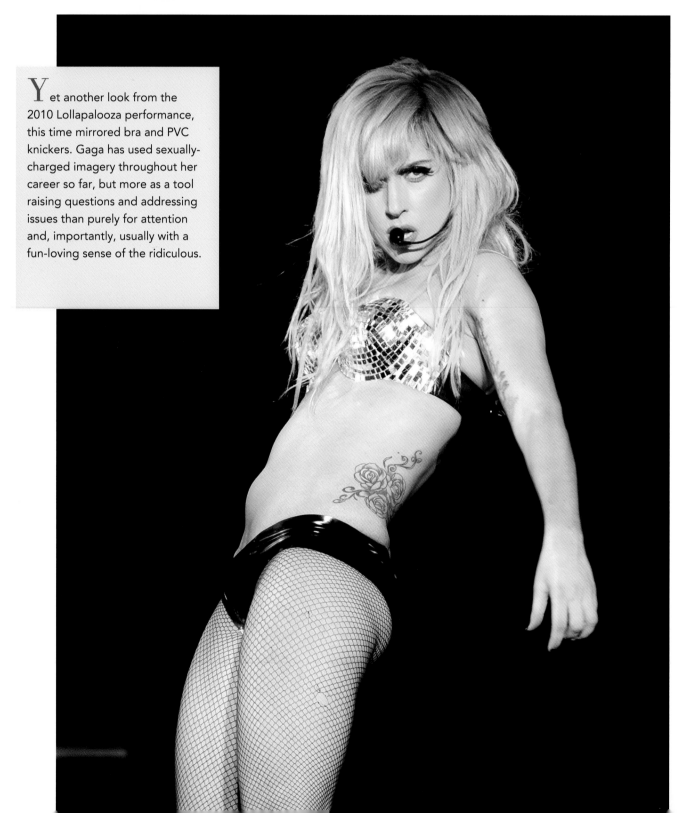

Yet another look from the 2010 Lollapalooza performance, this time mirrored bra and PVC knickers. Gaga has used sexually-charged imagery throughout her career so far, but more as a tool raising questions and addressing issues than purely for attention and, importantly, usually with a fun-loving sense of the ridiculous.

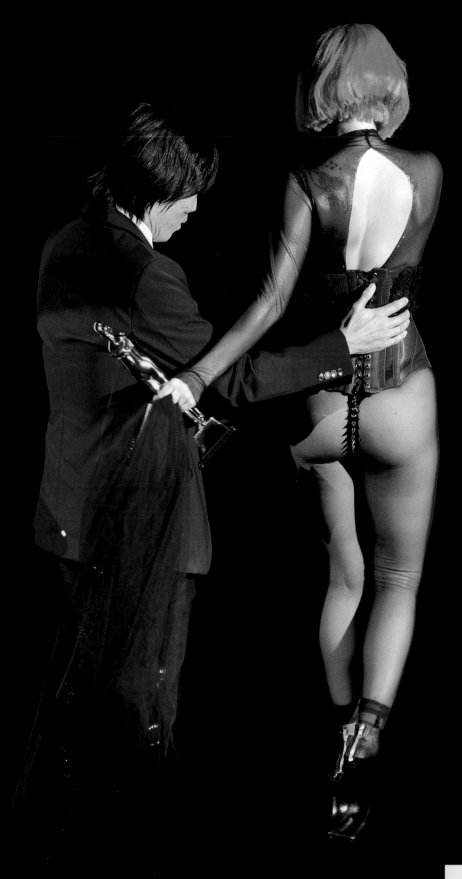

A helping hand is always useful, especially in these heels.

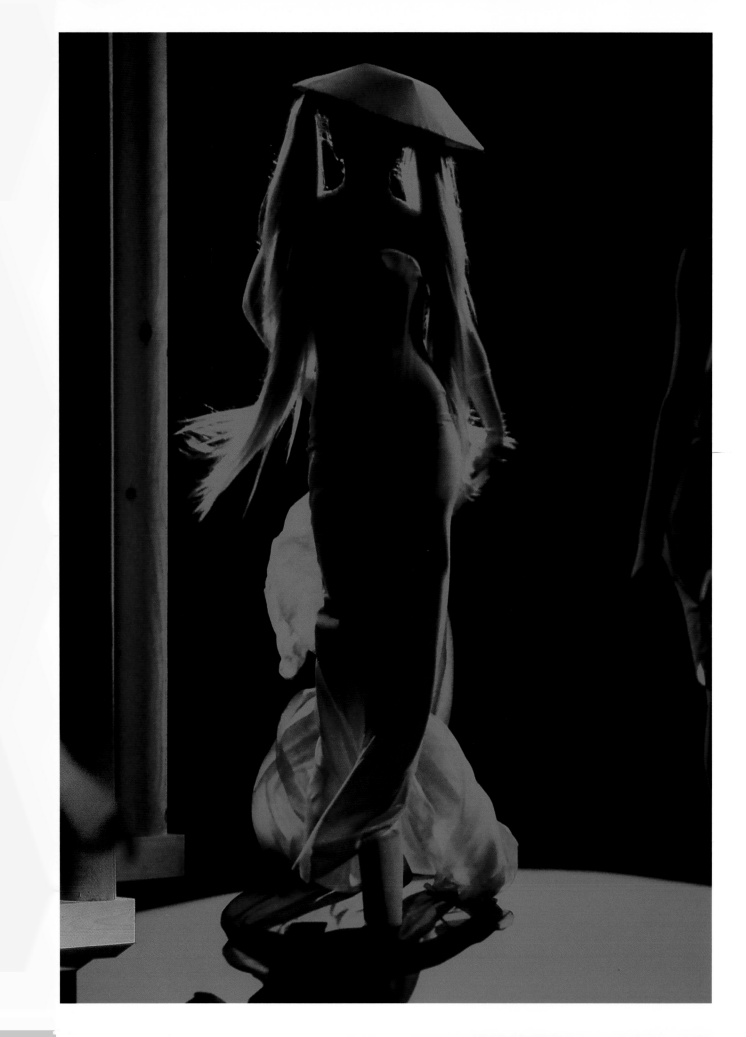

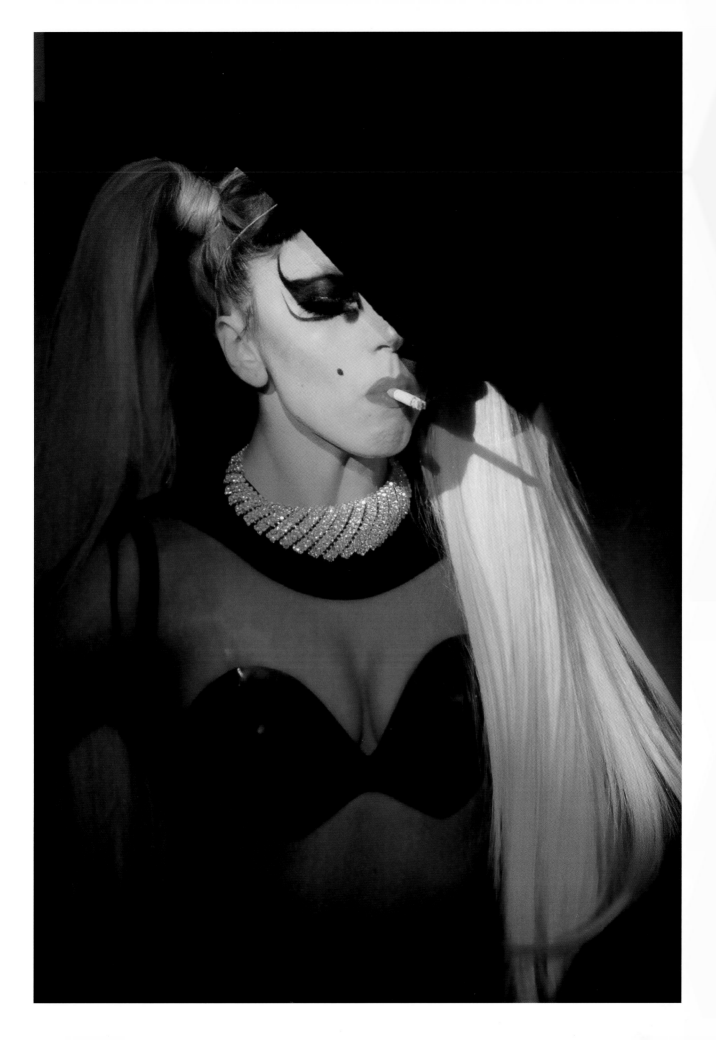

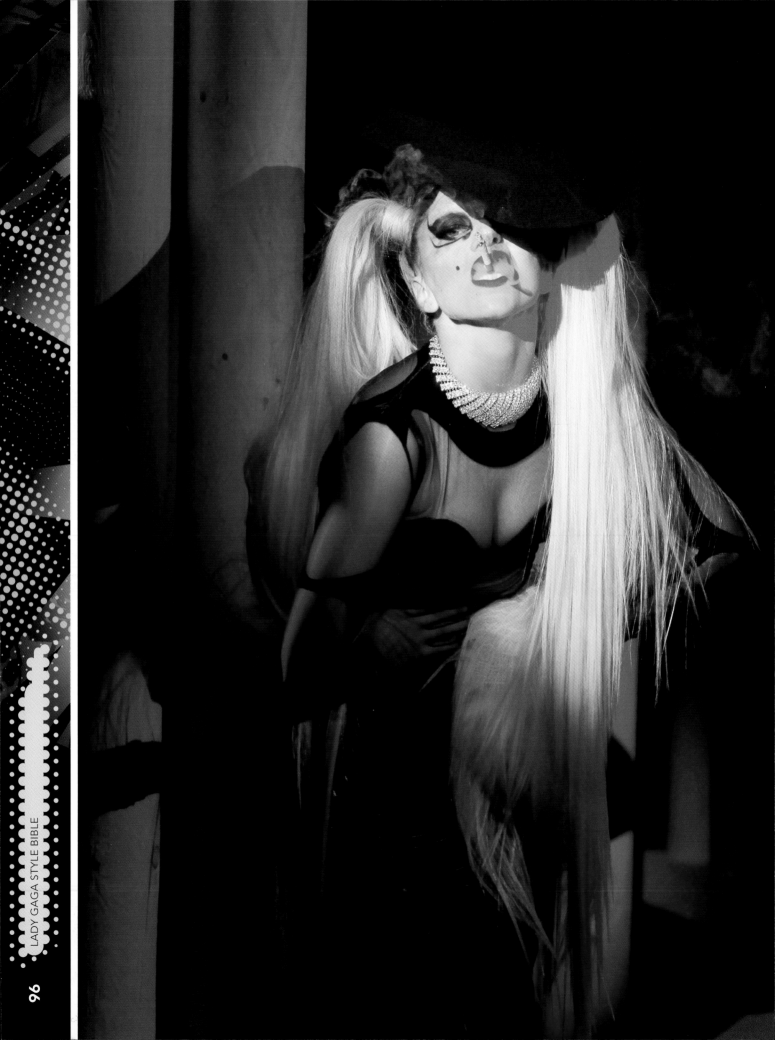

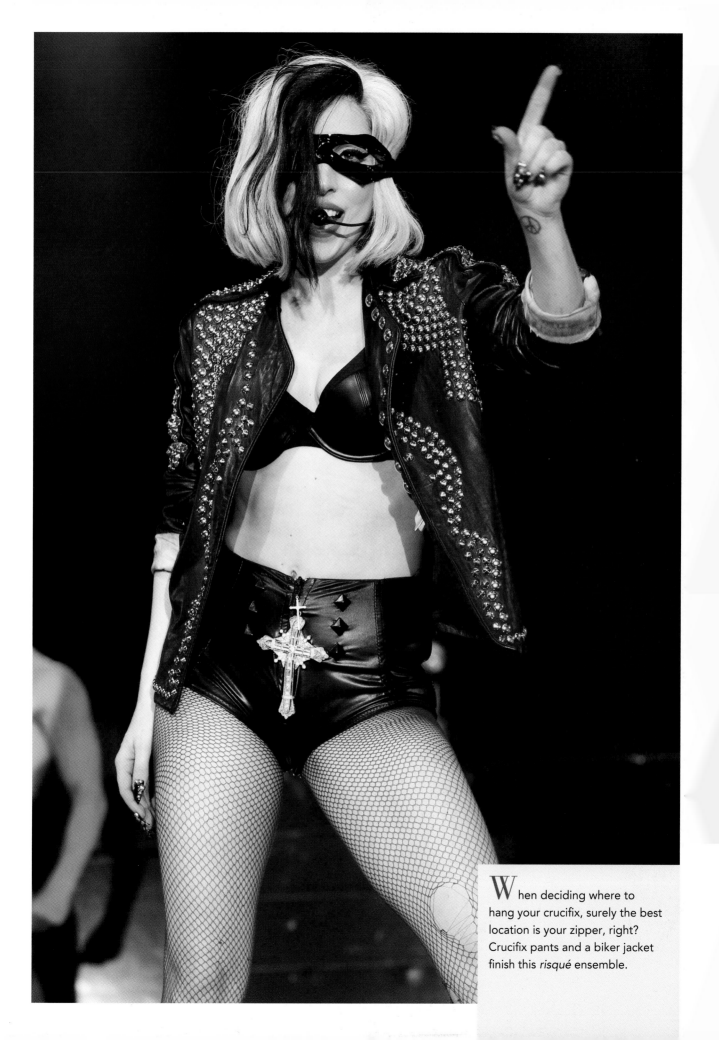

W hen deciding where to hang your crucifix, surely the best location is your zipper, right? Crucifix pants and a biker jacket finish this *risqué* ensemble.

 TOO MUCH

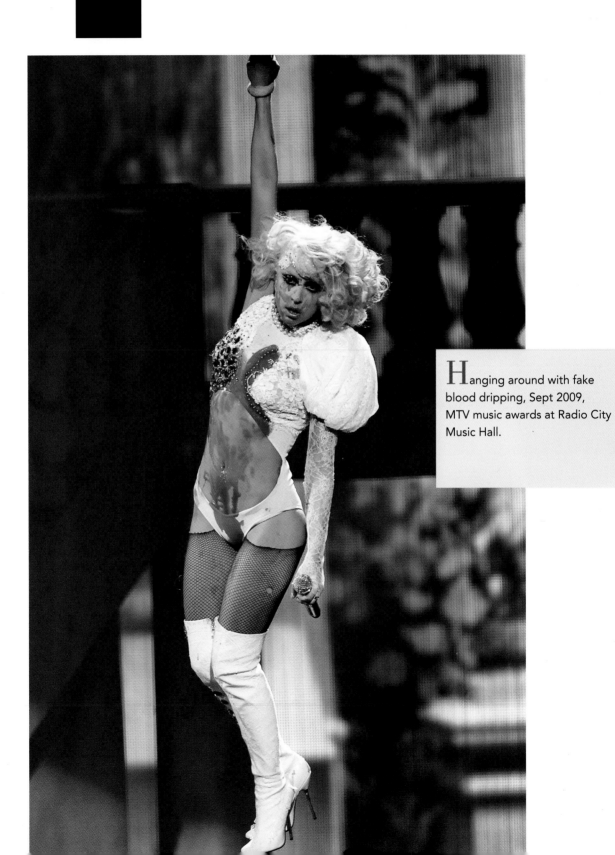

Hanging around with fake blood dripping, Sept 2009, MTV music awards at Radio City Music Hall.

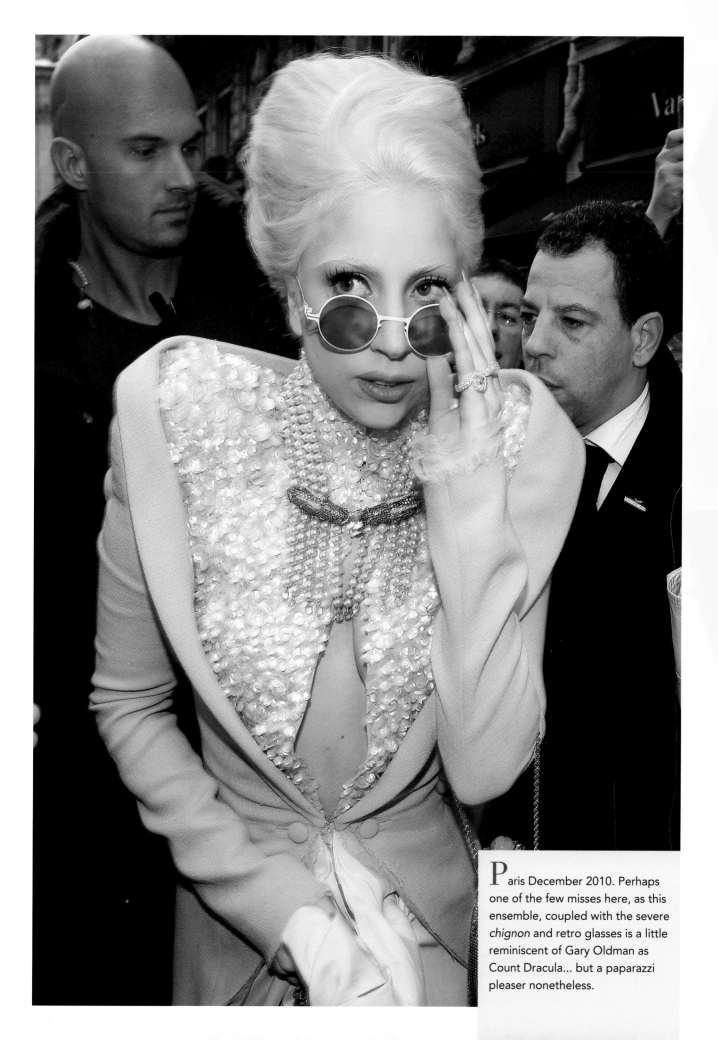

Paris December 2010. Perhaps one of the few misses here, as this ensemble, coupled with the severe *chignon* and retro glasses is a little reminiscent of Gary Oldman as Count Dracula... but a paparazzi pleaser nonetheless.

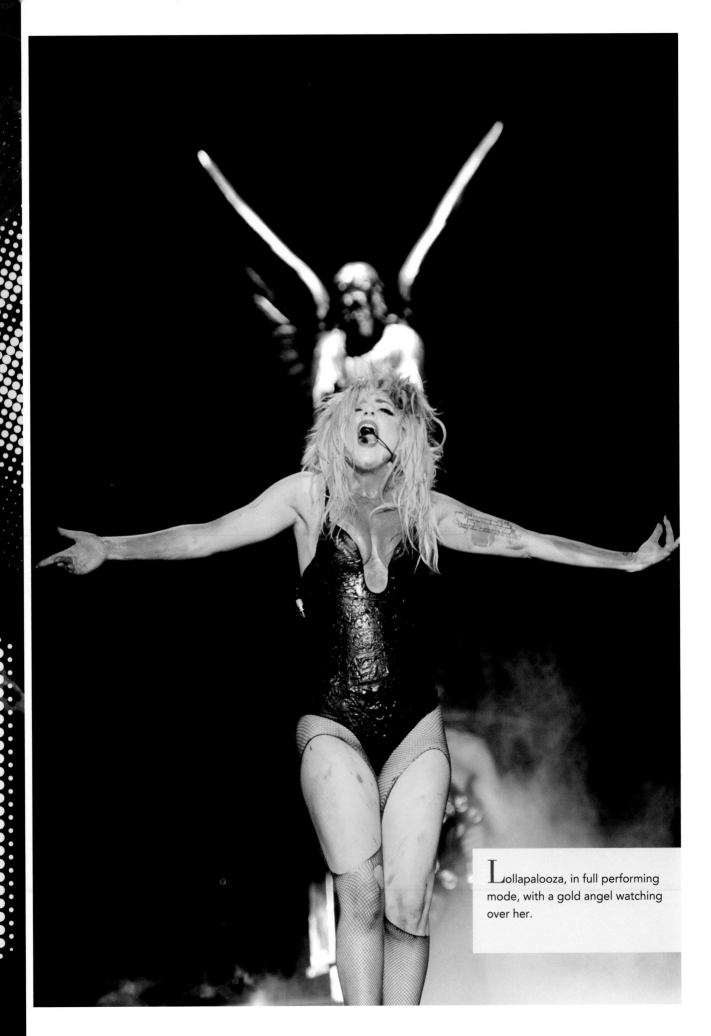

Lollapalooza, in full performing mode, with a gold angel watching over her.

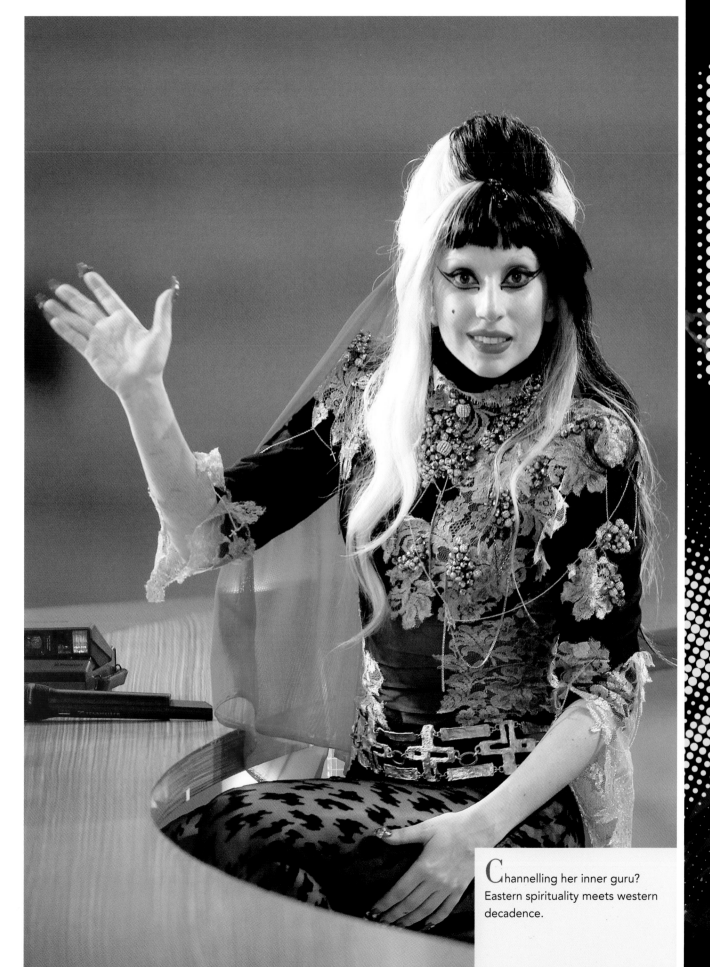

Channelling her inner guru?
Eastern spirituality meets western
decadence.

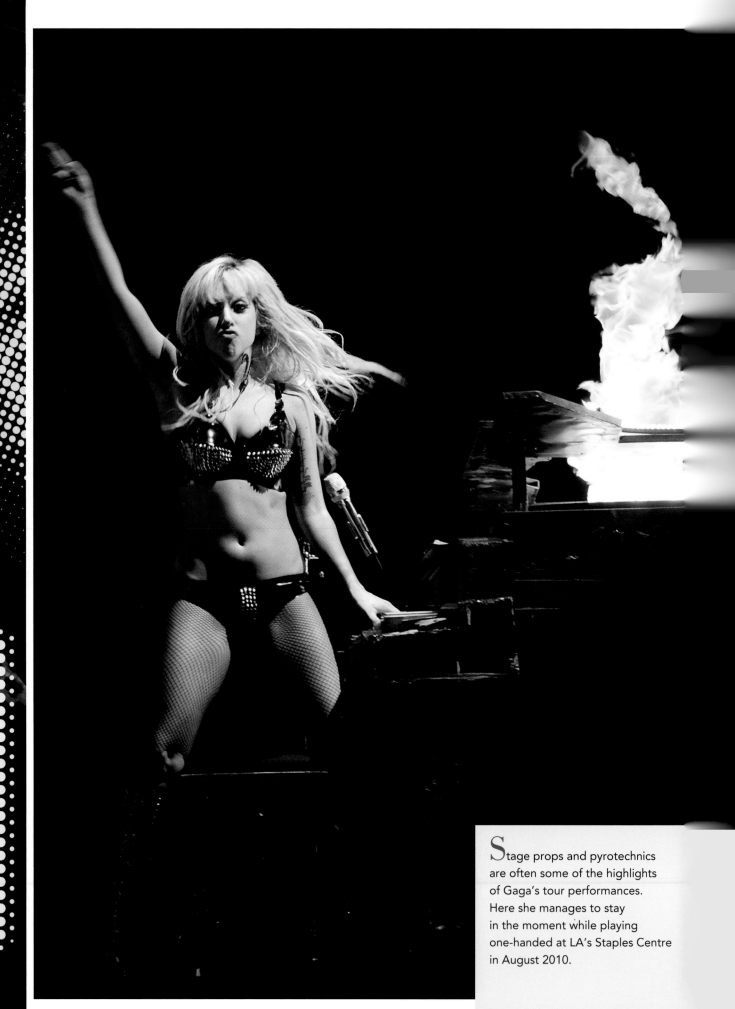

Stage props and pyrotechnics are often some of the highlights of Gaga's tour performances. Here she manages to stay in the moment while playing one-handed at LA's Staples Centre in August 2010.

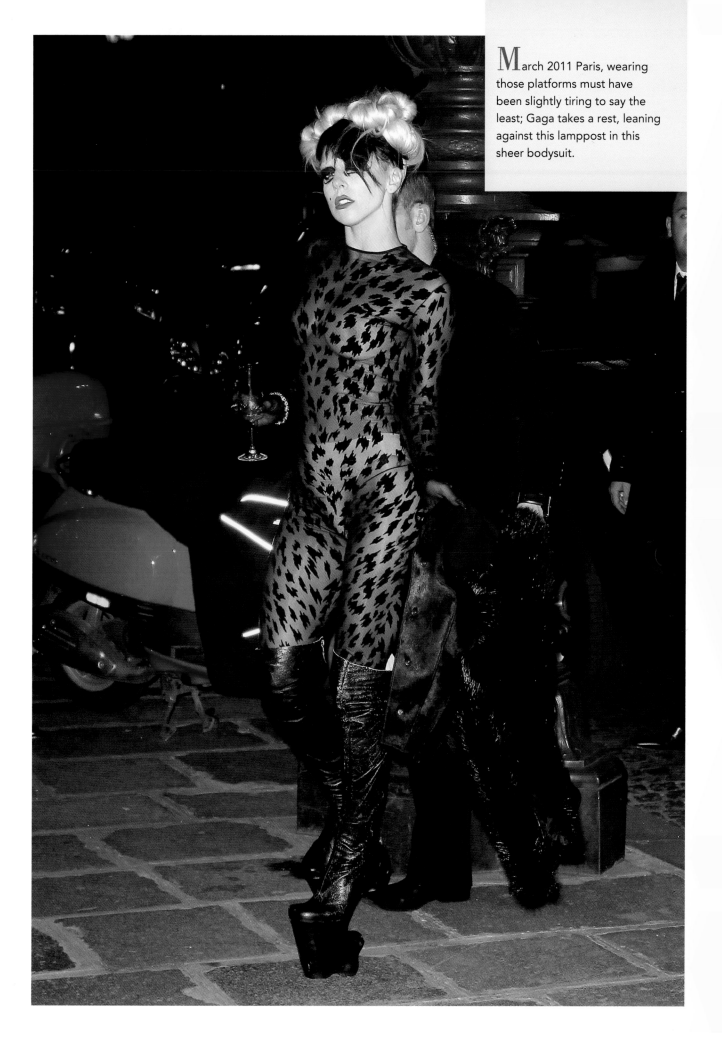

March 2011 Paris, wearing those platforms must have been slightly tiring to say the least; Gaga takes a rest, leaning against this lamppost in this sheer bodysuit.

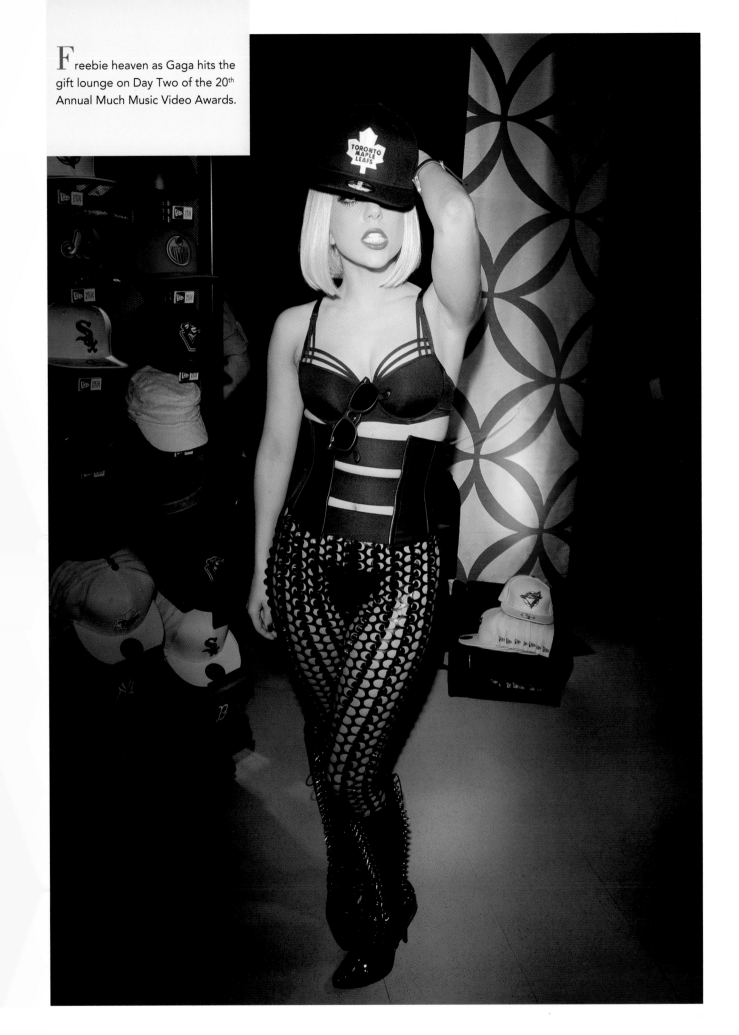

Freebie heaven as Gaga hits the gift lounge on Day Two of the 20th Annual Much Music Video Awards.

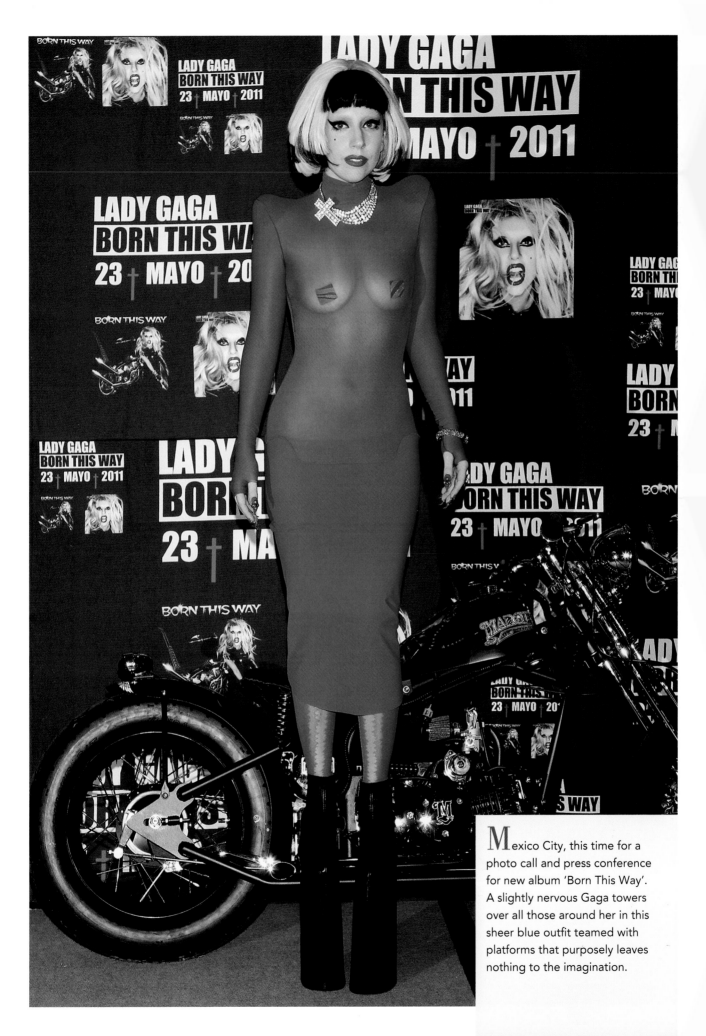

Mexico City, this time for a photo call and press conference for new album 'Born This Way'. A slightly nervous Gaga towers over all those around her in this sheer blue outfit teamed with platforms that purposely leaves nothing to the imagination.

Gaga performs at Palais Omnisports de Bercy in Paris, May 2010. Her body toned and sleek from constant touring, Gaga sets a great example to her fans and to young women everywhere with her body image. Although there's often a lot of flesh on display, Gaga has never taken up the trend of stick-like skeletal fashionableness beloved of so many young women in the spotlight today.

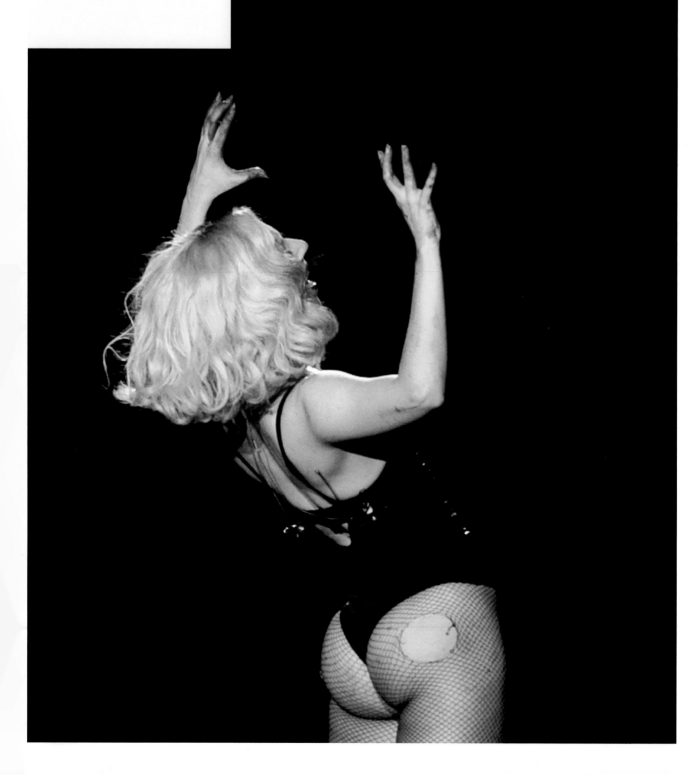

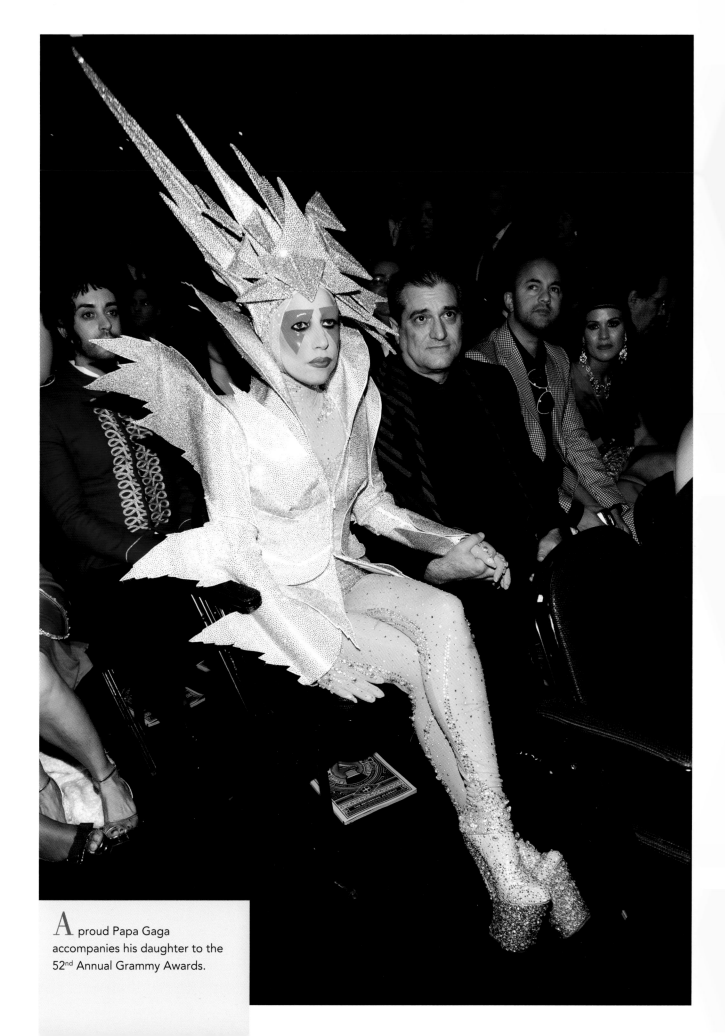

ULTIMATE GAGA

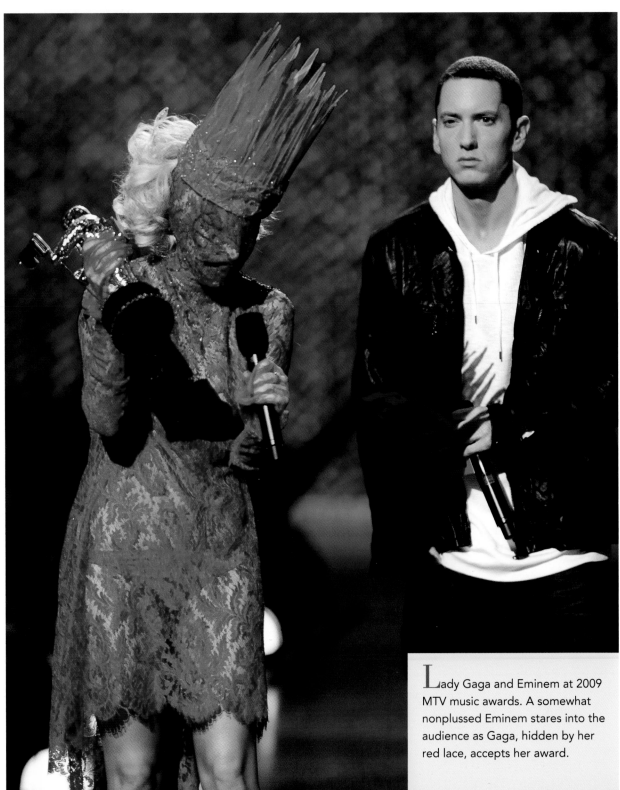

Lady Gaga and Eminem at 2009 MTV music awards. A somewhat nonplussed Eminem stares into the audience as Gaga, hidden by her red lace, accepts her award.

VICTORY MARCH

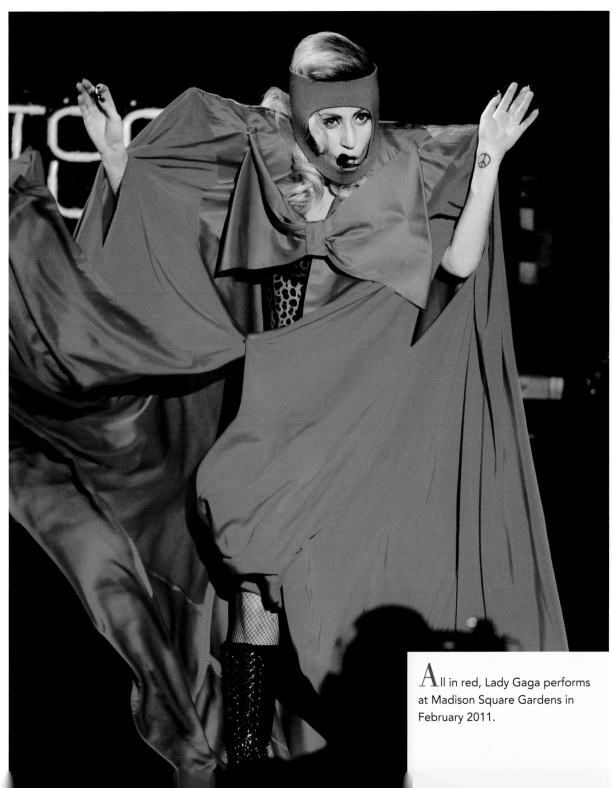

All in red, Lady Gaga performs at Madison Square Gardens in February 2011.

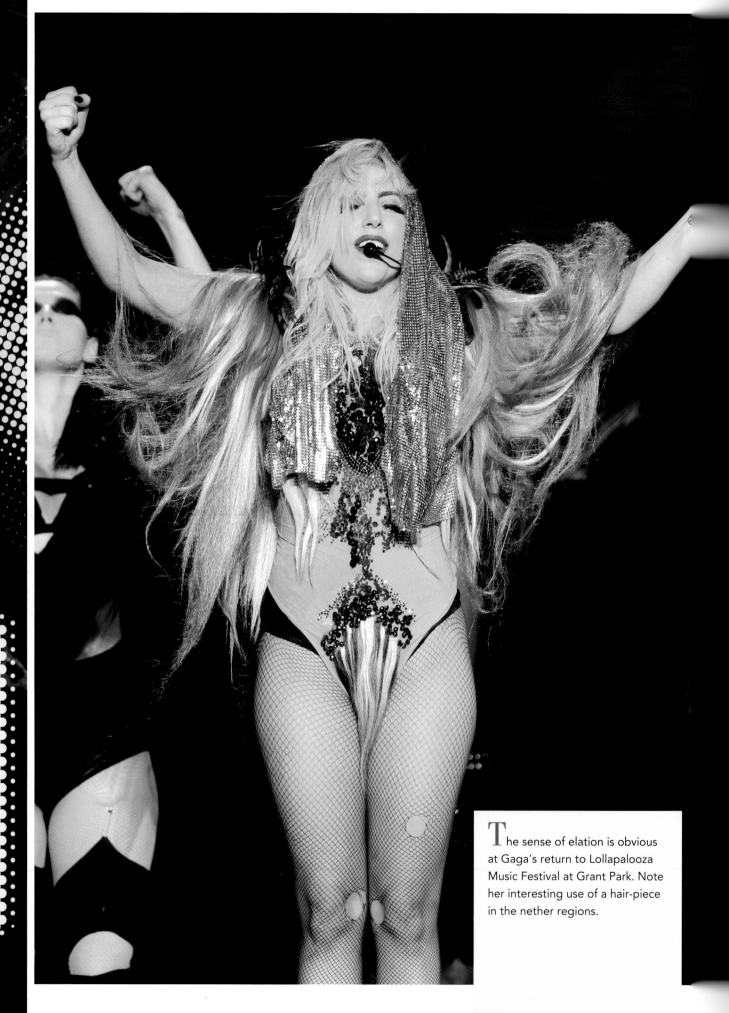

The sense of elation is obvious at Gaga's return to Lollapalooza Music Festival at Grant Park. Note her interesting use of a hair-piece in the nether regions.

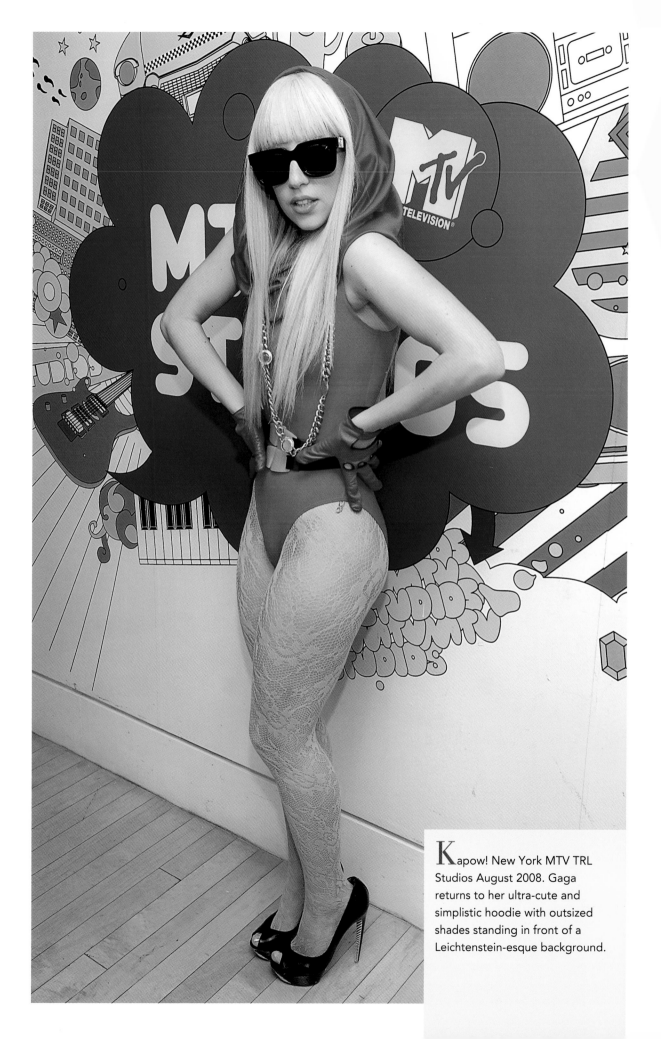

Kapow! New York MTV TRL Studios August 2008. Gaga returns to her ultra-cute and simplistic hoodie with outsized shades standing in front of a Leichtenstein-esque background.

WORLD CLASS ENTRANCE

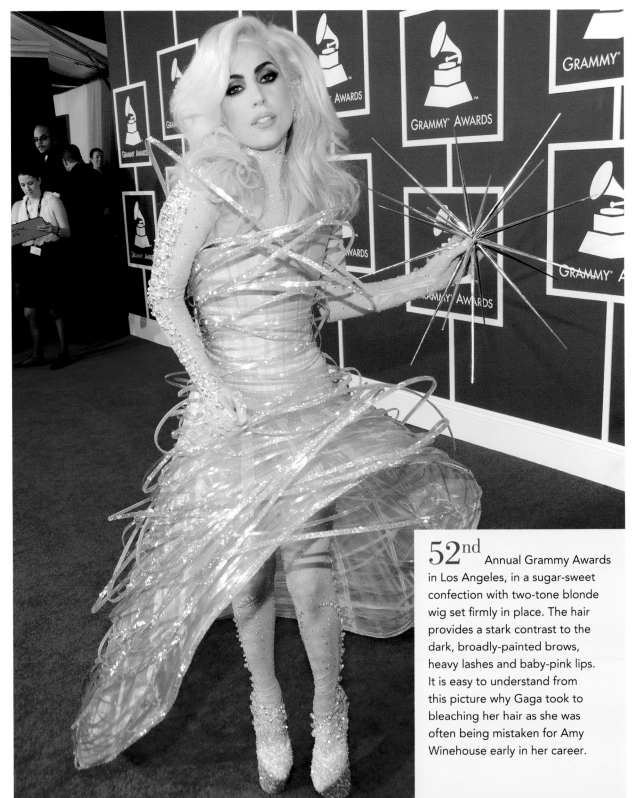

52nd Annual Grammy Awards in Los Angeles, in a sugar-sweet confection with two-tone blonde wig set firmly in place. The hair provides a stark contrast to the dark, broadly-painted brows, heavy lashes and baby-pink lips. It is easy to understand from this picture why Gaga took to bleaching her hair as she was often being mistaken for Amy Winehouse early in her career.

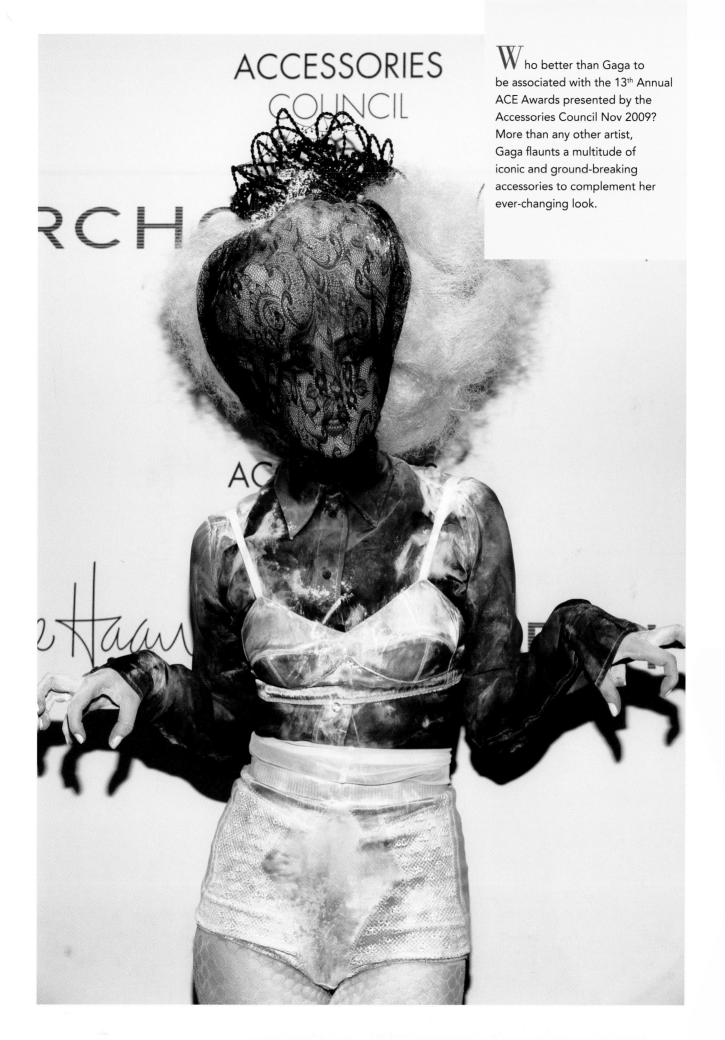

ACCESSORIES
COUNCIL

Who better than Gaga to be associated with the 13th Annual ACE Awards presented by the Accessories Council Nov 2009? More than any other artist, Gaga flaunts a multitude of iconic and ground-breaking accessories to complement her ever-changing look.

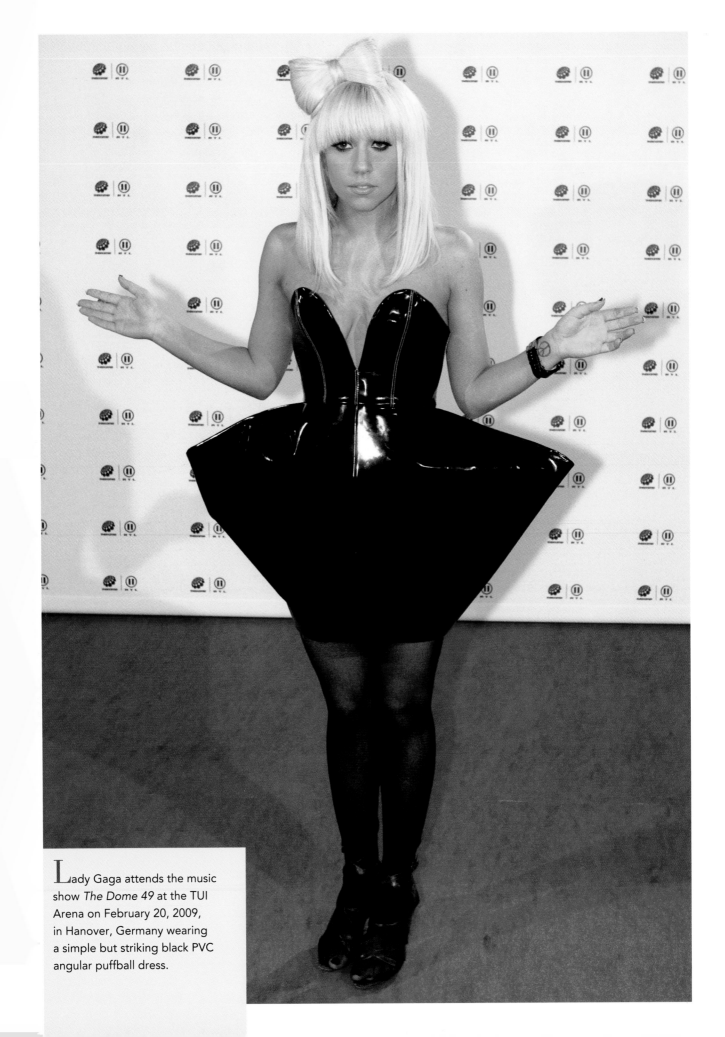

Lady Gaga attends the music show *The Dome 49* at the TUI Arena on February 20, 2009, in Hanover, Germany wearing a simple but striking black PVC angular puffball dress.

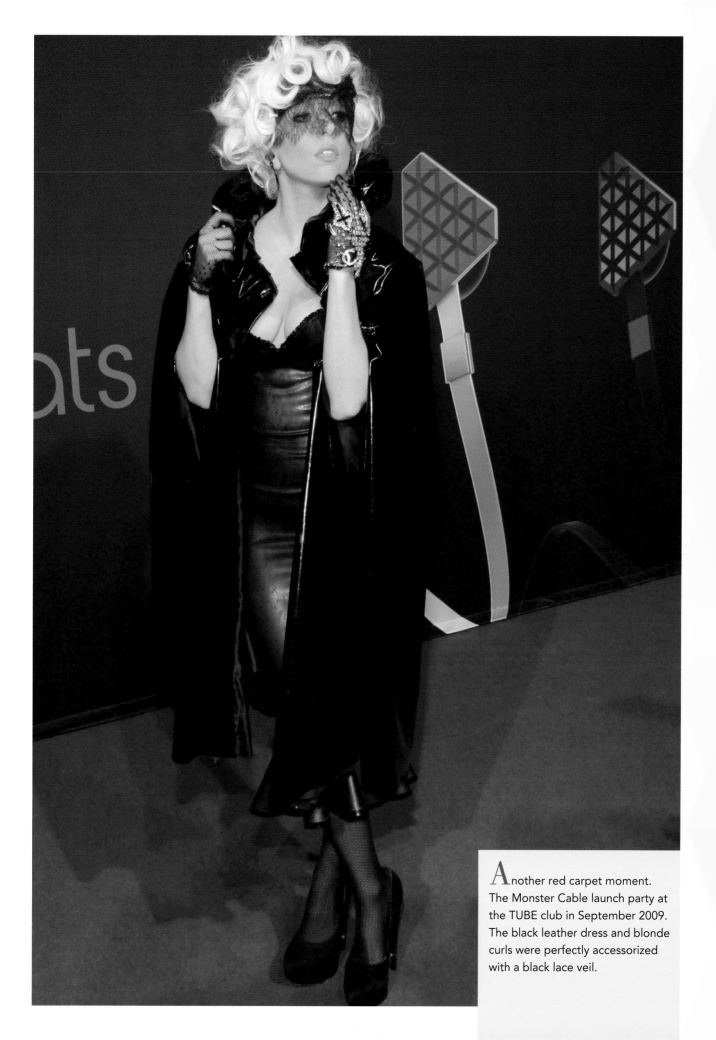

Another red carpet moment. The Monster Cable launch party at the TUBE club in September 2009. The black leather dress and blonde curls were perfectly accessorized with a black lace veil.

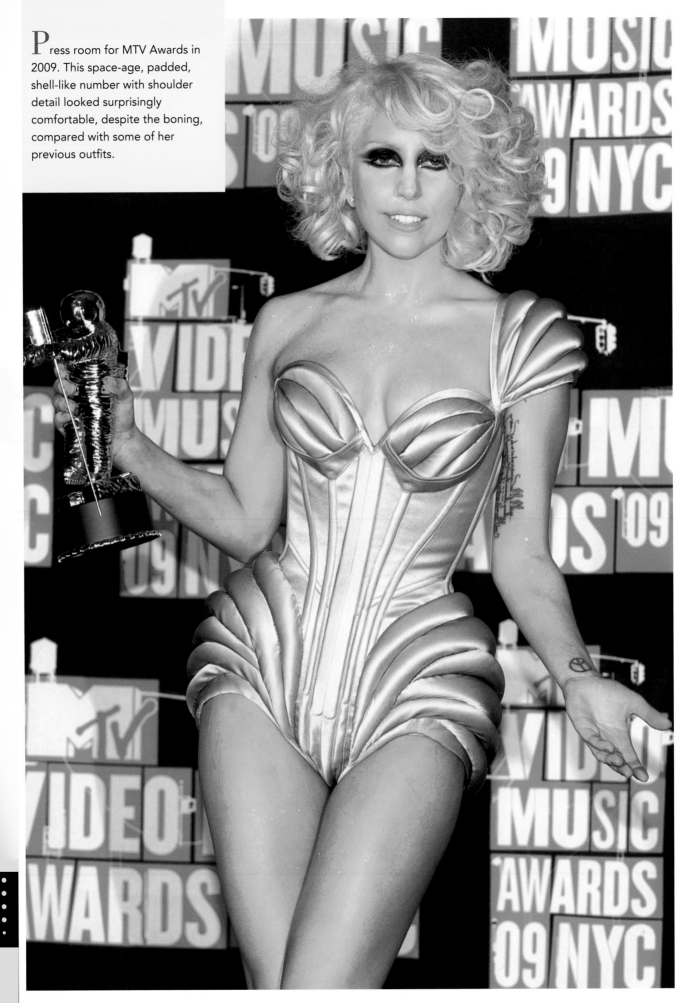

Press room for MTV Awards in 2009. This space-age, padded, shell-like number with shoulder detail looked surprisingly comfortable, despite the boning, compared with some of her previous outfits.

Wearing a majestic white lace head-dress, Gaga attends the VMA afterparty in New York City, September 2009.

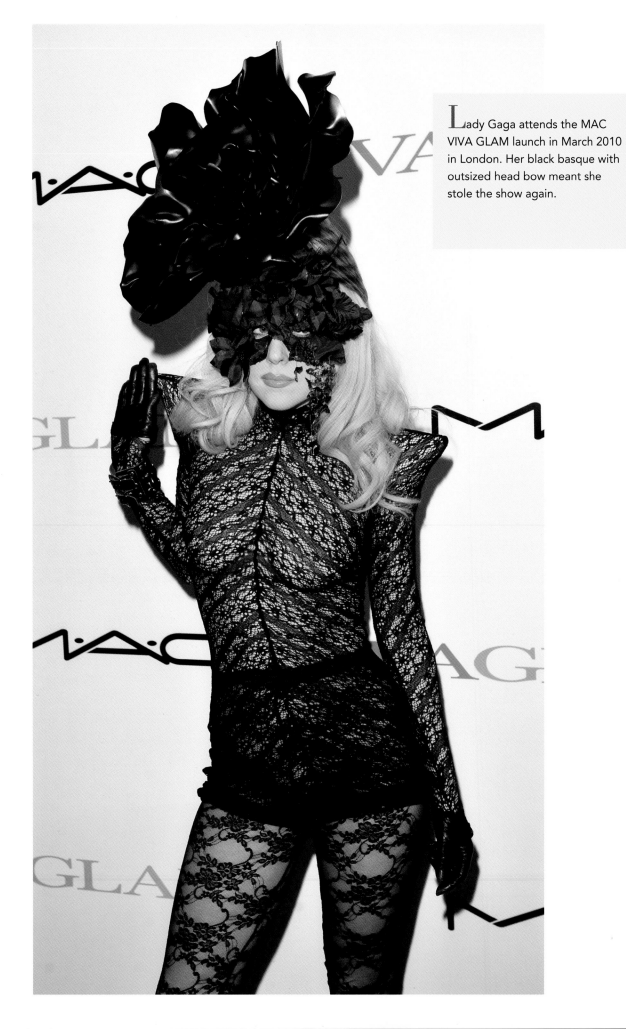

Lady Gaga attends the MAC VIVA GLAM launch in March 2010 in London. Her black basque with outsized head bow meant she stole the show again.

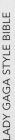

Gaga was accused of selling out by sporting this Hermes Birkin bag, but she kept it real by scribbling a message for her Tokyo fans on the bag in Japanese.

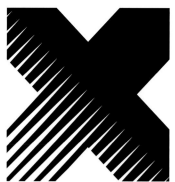

XSTATIC PROCESS

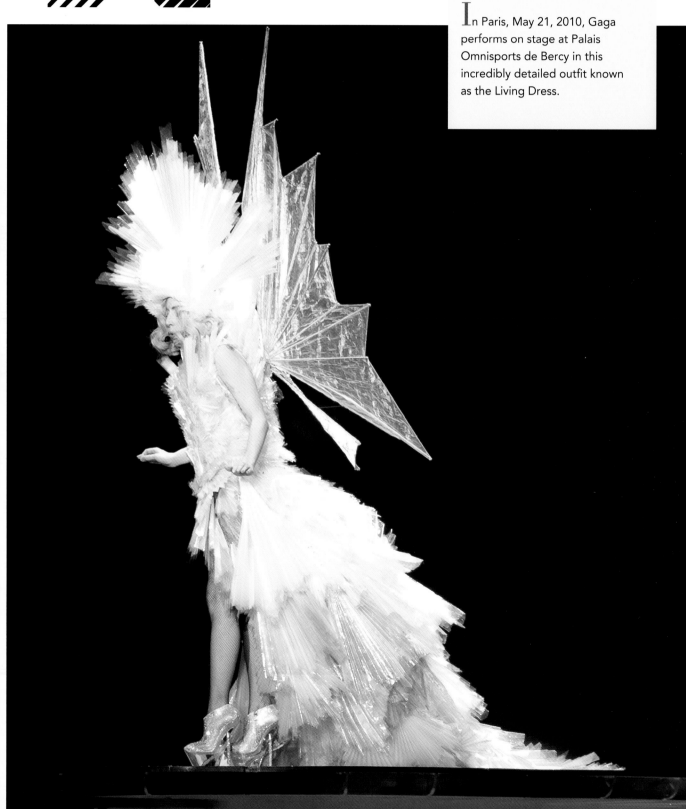

In Paris, May 21, 2010, Gaga performs on stage at Palais Omnisports de Bercy in this incredibly detailed outfit known as the Living Dress.

Y YESTERDAY'S DREAMS SEEM SO LONG AGO

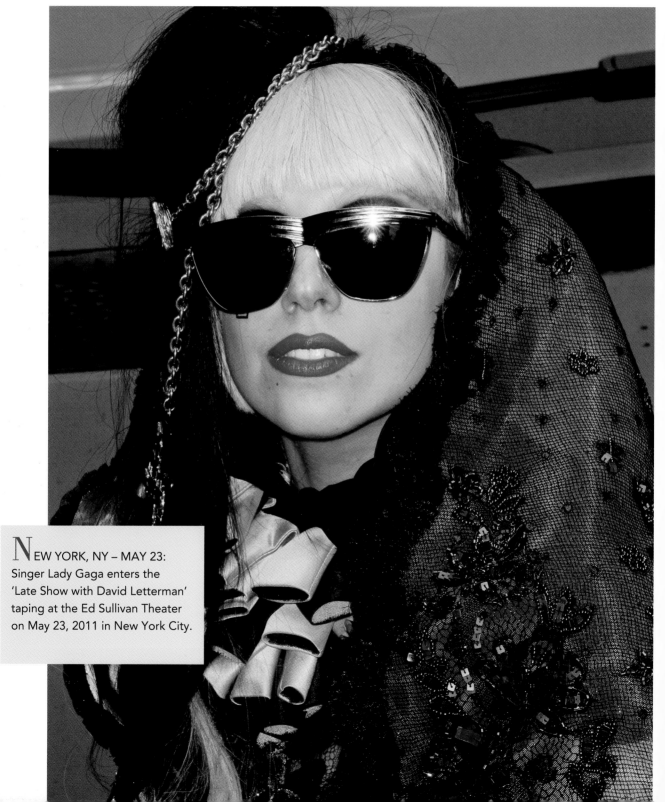

NEW YORK, NY – MAY 23:
Singer Lady Gaga enters the
'Late Show with David Letterman'
taping at the Ed Sullivan Theater
on May 23, 2011 in New York City.

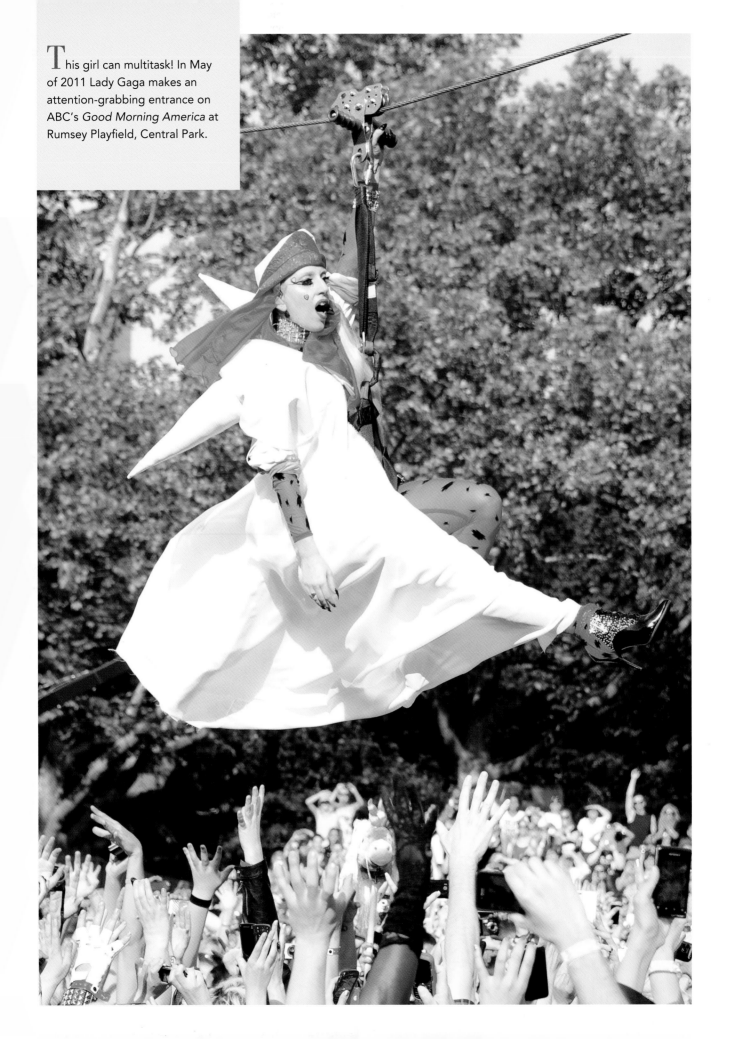

This girl can multitask! In May of 2011 Lady Gaga makes an attention-grabbing entrance on ABC's *Good Morning America* at Rumsey Playfield, Central Park.

Z LIST
TO A LIST

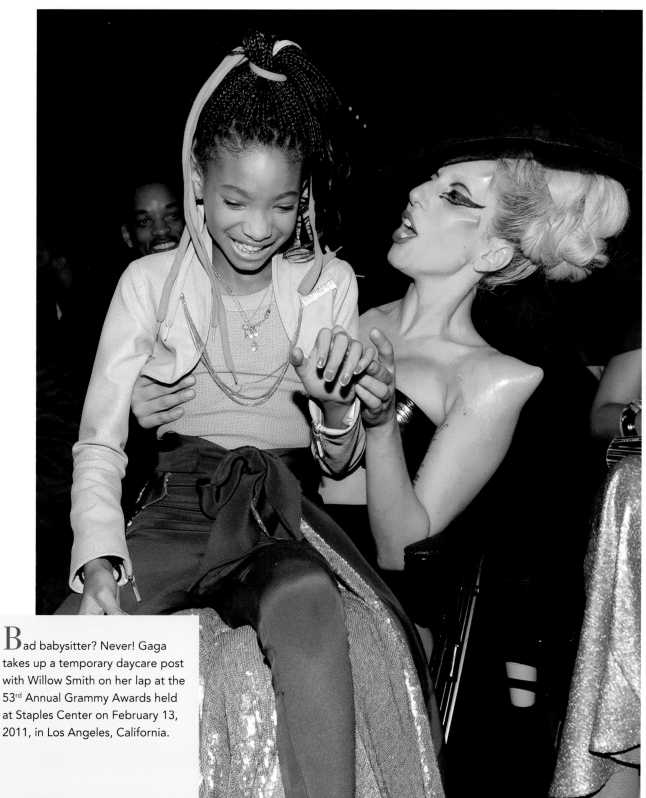

Bad babysitter? Never! Gaga takes up a temporary daycare post with Willow Smith on her lap at the 53rd Annual Grammy Awards held at Staples Center on February 13, 2011, in Los Angeles, California.

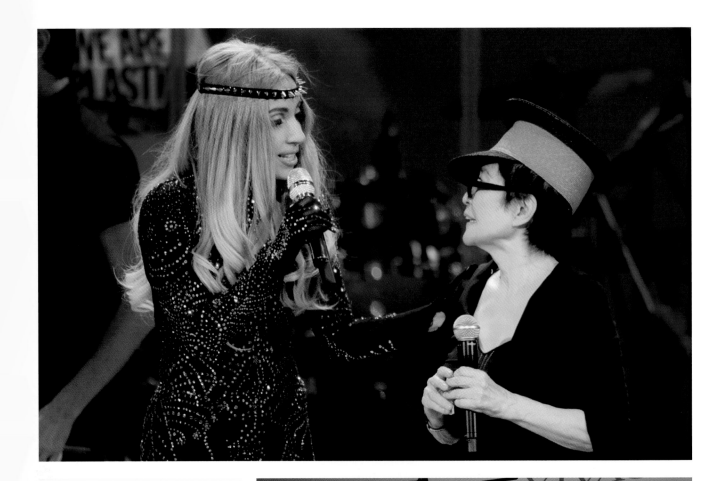

Many observers see Madonna as the performer that Gaga often looks to for inspiration, but Yoko Ono is also a perfect reference point. Both performers combine music and visuals with a strong sense of artistic purpose.

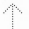

In London Lady Gaga hooked up with Cyndi Lauper to attend the MAC VIVA GLAM launch hosted by Sharon Osbourne. This was to promote MAC's latest fundraising range and all the proceeds went toHIV/AIDs charities via the MAC AIDS Fund, a cause close to Gaga's heart.

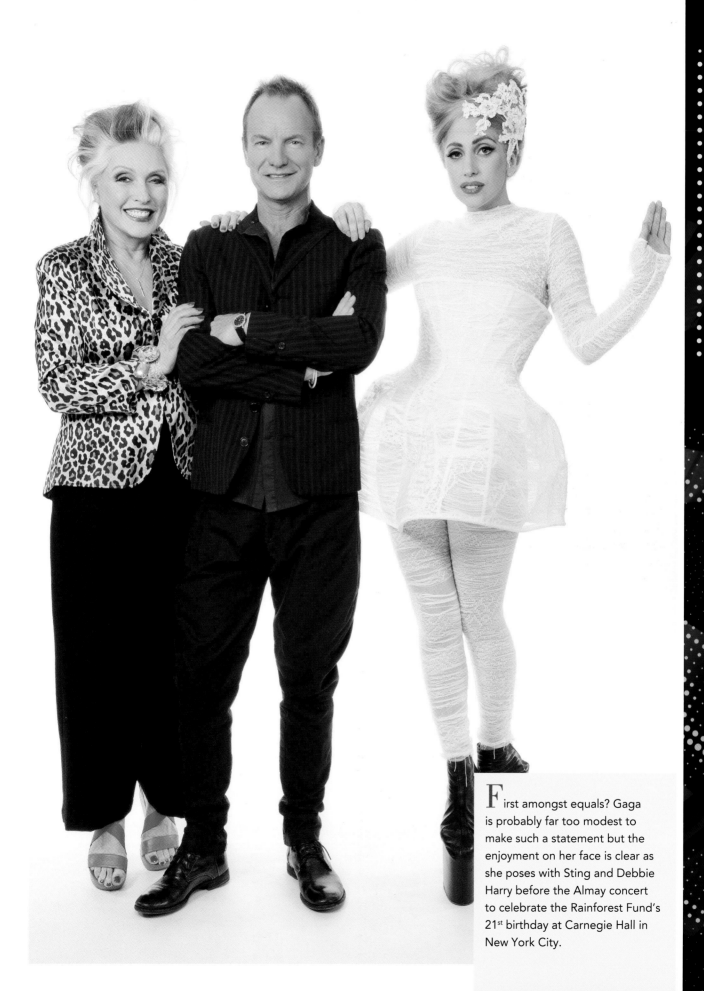

First amongst equals? Gaga is probably far too modest to make such a statement but the enjoyment on her face is clear as she poses with Sting and Debbie Harry before the Almay concert to celebrate the Rainforest Fund's 21st birthday at Carnegie Hall in New York City.

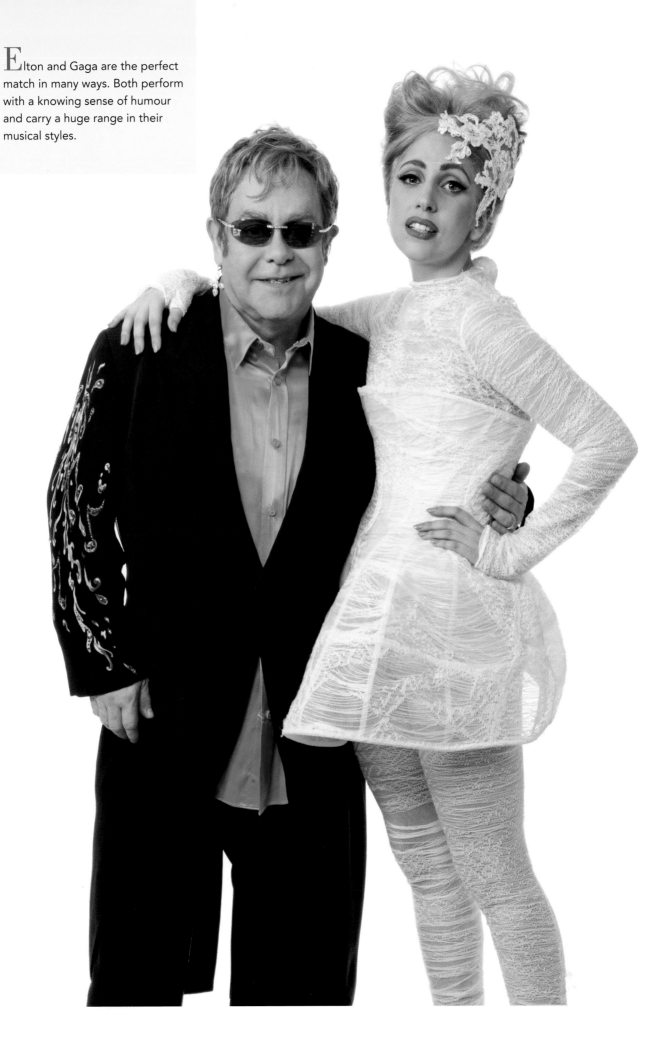

Elton and Gaga are the perfect match in many ways. Both perform with a knowing sense of humour and carry a huge range in their musical styles.

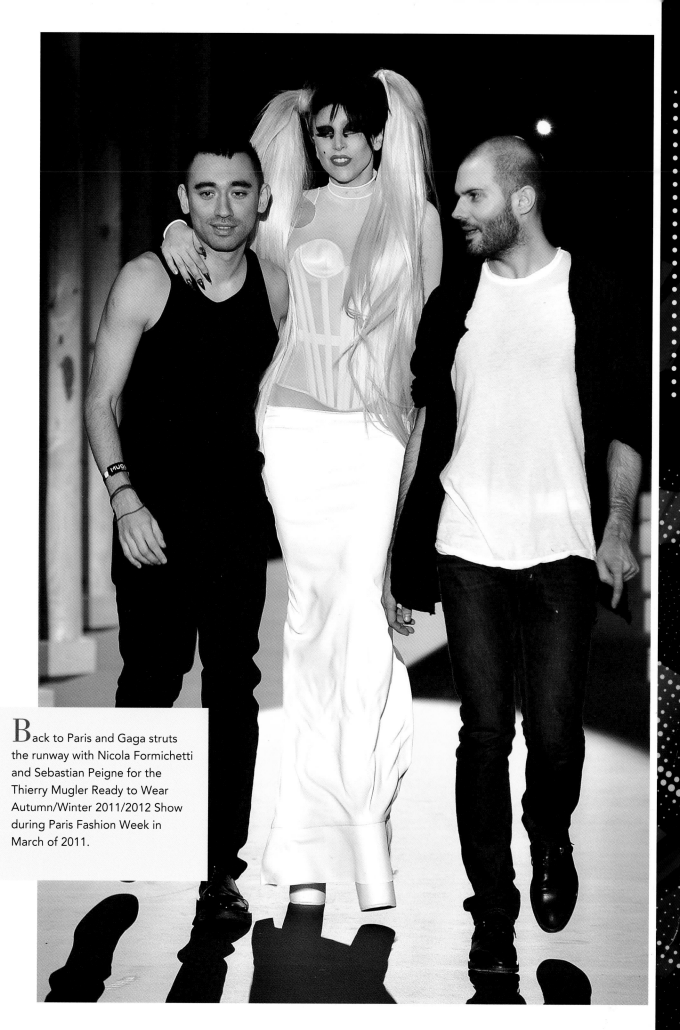

Back to Paris and Gaga struts the runway with Nicola Formichetti and Sebastian Peigne for the Thierry Mugler Ready to Wear Autumn/Winter 2011/2012 Show during Paris Fashion Week in March of 2011.